ZIEGLER

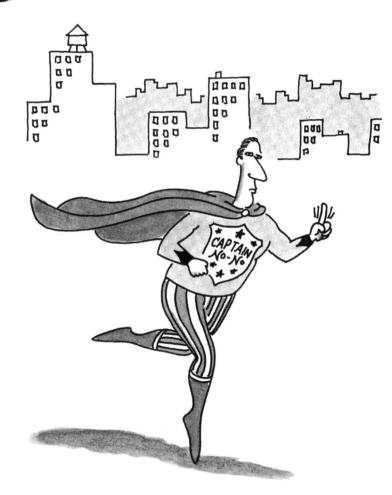

The Essential Jack Ziegler

COMPILED AND EDITED BY LEE LORENZ

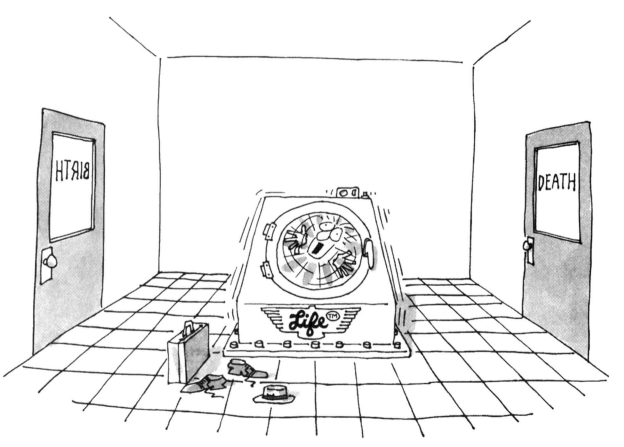

WORKMAN PUBLISHING · NEW YORK

A Lee Lorenz Book

For Kelli
J.Z.

For Sally Kovalchick
L.L.

Of the 170 drawings in this collection, 139 originally appeared in *The New Yorker* and were copyrighted ©
in the years 1974 through 2000 inclusive by The New Yorker Magazine, Inc.

Library of Congress Cataloging-in-Publication Data

The essential Jack Ziegler / compiled and edited by Lee Lorenz.
p. cm.
"A Lee Lorenz book."
ISBN 0-7611-1758-X (alk. paper)
1. Ziegler, Jack—Interviews. 2. Cartoonists—United States—Interviews.
3. American wit and humor, Pictorial. I. Lorenz, Lee.

NC1429.Z47 A35 2000
741.5'092—dc21 00-043714

Workman books are available at special discounts when purchased in bulk for premiums and sales promo-
tions as well as for fund-raising or educational use. Special editions can also be created to specification. For
details, contact the Special Sales Director at the address below.

Workman Publishing Company, Inc.
708 Broadway
New York, NY 10003-9555
www.workman.com

Printed in the United States of America

First printing November 2000
10 9 8 7 6 5 4 3 2 1

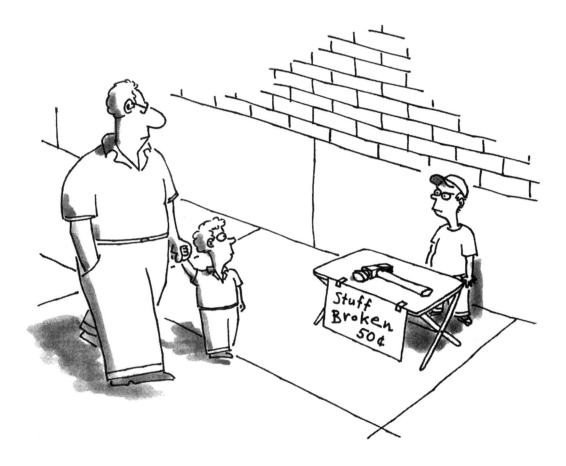

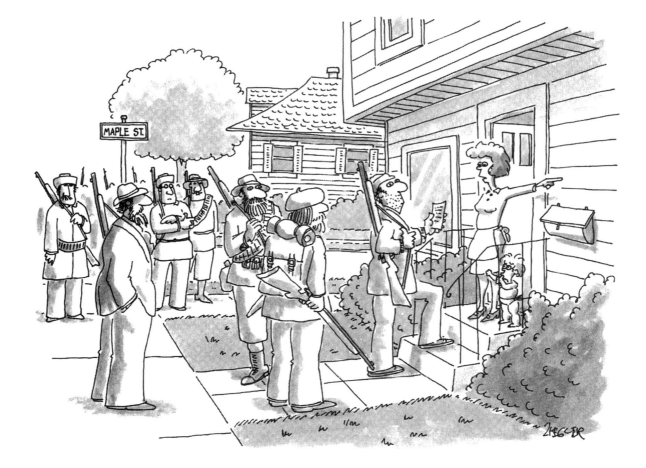

"I'm sorry, but this is the home base for the moderate rebel faction. You want the fundamentalist guerrilla organization, which is over on Elm Street."

PREFACE

Jack Ziegler is the least likely revolutionary since Woody Allen in *Bananas*. His manner, as befits a graduate of Xavier Military High School, is polite and deferential. Like many tall people (Jack is 6'4"), he moves cautiously, as if anticipating a low door frame. These days he sports a sea captain's beard. The hair on his head is randomly spaced and cropped short. Jack is soft-spoken, and his conversation is peppered with qualifiers and disclaimers: "sort of," "perhaps," "so to speak," "maybe." Although he grew up in the foulmouthed sixties, his expletive of choice remains the quaintly old-fashioned "ridiculous!"

About his own work Jack is unfailingly modest. To interviewers he describes his ambition as "just wanting to be funny." This is about as helpful as Robin Williams saying he just wants to be short. The truth is that, without a subversive thought in his head, Jack Ziegler redefined what a gag cartoon could be.

To what extent this was the result of individual talent or a shift in zeitgeist is a matter of speculation. The upheavals of the sixties left many young people with little more than a coffee can full of hash and a strong sense of entitlement. For a gifted few, however, the period stimulated new approaches to traditional forms: Donald Barthelme in literature, for example, or Ornette Coleman in jazz and Andy Warhol in painting. (The influential philosopher and art critic Arthur C. Danto has proposed that art history itself—that is, the traceable arc of western painting and sculpture from the Renaissance forward—ended in the mid-sixties.)

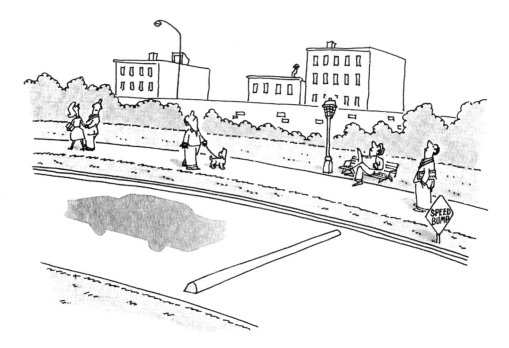

All these artists, like Jack, shared a drive to shatter existing conventions. Their common tool kit was, like Jack's, parody and pastiche.

The work Ziegler began publishing in the early seventies seamlessly blended the conventions of the comic strip and the traditional format of the captioned gag cartoon. The resulting hybrid created echoes in the work of such established artists as Mischa Richter, Charles Barsotti, and Charles Addams. More important, it prepared the ground for a whole new generation of comic artists including Mick Stevens, Robert Mankoff, Richard Cline, and Roz Chast.

For Jack, such high-flown analysis is merely embarrassing. His ambition remains what it was when he started out—to make people laugh.

—Lee Lorenz

CONTENTS

HARRY FENT, HUMAN BEING

DISCLAIMER: MR. FENT IS PURELY A CREATION OF THE ARTIST'S IMAGINATION, AND ANY RESEMBLANCE TO PERSONS LIVING OR DEAD IS PURELY COINCIDENTAL. ALSO, ONE SHOULD NOT ASSUME THAT THIS DEPICTION OF A HUMAN BEING IS AN INDICTMENT OF ALL HUMAN BEINGS PER SE. FURTHER, THE ARTIST DOES NOT ADVOCATE THE ABOVE MANNER OF DRESS, HAIR STYLE, OR BODY LANGUAGE. AND THE FACT THAT THIS DRAWING IS RENDERED TWO-DIMENSIONALLY AND IN BLACK-AND-WHITE DOES NOT PRECLUDE POSSIBLE FUTURE COLOR OR HOLOGRAPHIC RENDERINGS. FINALLY, THE ARTIST APOLOGIZES FOR WRITING THIS DISCLAIMER IN ENGLISH ONLY. TRANSLATIONS INTO OTHER TONGUES ARE AVAILABLE UPON REQUEST.

FAMILY ALBUM

To most of the world, New York City means Manhattan. In fact, the city comprises five boroughs—Manhattan, Brooklyn, the Bronx, Staten Island, and Queens. Brooklyn has its bridge, the Bronx has its Bombers, Staten Island has its ferry, and Queens has—well, Queens has the Ramones (Godfathers of Punk Rock), former Governor Mario Cuomo, and, from the Archie Bunker side of Queens Boulevard, Jack Ziegler.

JACK: I was born in Brooklyn on July 13, 1942. My father was from Brooklyn —Flatbush—and my mother grew up in Queens. We moved to Queens the day after I was born, or possibly two days after, and I grew up in the same house in Forest Hills that my mother grew up in. When she was a kid, back in the days of silent movies, they used to shoot Westerns in that neighborhood.

LEE: What about your grandparents?

JACK: My mother's parents were from Ireland. One of my father's parents was from Ireland, the other from Germany. Both grandfathers were dead by the time I came along. My mother's mother lived with us for a while before she died. My paternal grandmother lived in Rockaway, near the ocean.

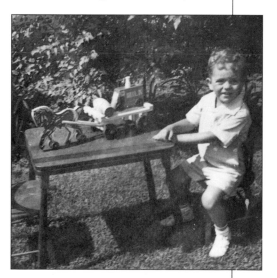

The crown prince
of Queens.

1

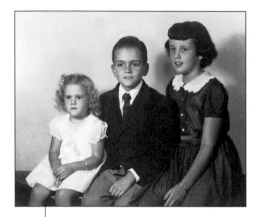

LEE: Any artists on either side of the family?

JACK: My mother studied art in college. She did a little fashion design for a while, newspaper drawings of fashion, but I don't think she really pursued art. She did continue to paint and draw, but she wasn't really serious about it. She eventually taught grade school.

LEE: What about your father?

JACK: My dad was a paint salesman. He worked for Eakins Pigments, which supplied manufacturers all over the tristate area. I got my earliest art supplies from him, via the Eakins supply room.

LEE: And you have two sisters?

JACK: Two sisters—one two years older, one five years younger.

LEE: I assume you were closer to your older sister.

JACK: Yeah, well, before the other one was born.

Jack with sisters Beth and Kathy (above), best friend (right), and chums at beach (opposite).

THE VIEW FROM QUEENS

LEE: What was it like to grow up in Forest Hills?

JACK: Well, Forest Hills has always been sliced in two by Queens Boulevard. In my day, the good side had the West Side Tennis Club, where the U.S. Open tennis tournament was played, and Forest Hills Gardens, a community of single-family homes where the martini set lived. Our side of the Boulevard was where the "What else have you got to drink?" set lived. The houses on our side were interspersed with apartment buildings, and the streets all had numbers instead of fancy British-sounding names.

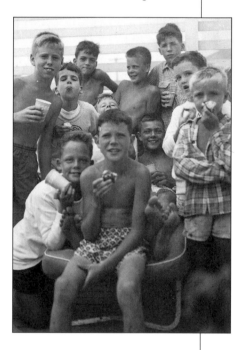

I think I had a pretty normal childhood. We occasionally had dogs. I watched TV—*Gunsmoke* and *Father Knows Best,* but my favorite was *Flash Gordon* with Buster Crabbe. In addition to swapping comic books, I traded baseball cards. I loved going to the movies, and I loved music—rhythm and blues, doo-wop, and almost any rock and roll; when I was thirteen or so, I went to Alan Freed's shows at the Brooklyn Paramount. And I drew all the time. There were no art classes at school, so I just worked on my own. I used a plain old fountain pen with blue ink. I copied stuff from comic books, of course, but I also worked from photos in *Life* and *Look.* I was nuts about Civil War scenes. My most ambitious project was *The Battle of Gettysburg,* but after drawing about sixty figures I gave up.

My family was Catholic, and my mother insisted I be an altar boy.
I hated it. There seemed to be Masses all week long. The only
good things were weddings and funerals, where sometimes
they gave you tips. I spent all I made on comic books. I had
my own bedroom, and my collection filled the closet and spilled
under the bed. They were mostly EC comics: *Weird Science*,
Tales from the Crypt, and so on. I also liked *Blackhawk*,
but I couldn't abide *Superman* and *Batman* or any of the
other superheroes. What I liked was implausible but not
impossible.

I remember the Kefauver hearings. Everyone was afraid
comic books were corrupting the nation's youth, but my
parents never made much of a fuss. They probably
figured that if I had any subversive tendencies,
the nuns at school would knock them out of me.

I went to elementary school at Our Lady
Queen of Martyrs. There were about eighty kids in
my class, and the discipline was very strict. If you got out of line, you got hit
with whatever was handy; if that failed, you got detention. I got whacked a
few times, but I managed to avoid detention. High school was even tougher.
I went to Xavier Military High School, a Jesuit school on West Sixteenth Street
in Manhattan. They had a "prefect of discipline" to maintain order. He did.
Despite his being a priestly man of peace, he once grabbed the kid next to me
and threw him across the room into a blackboard. I remember another teacher
who used to zap unruly students with little pieces of chalk. I don't know how
he did it, but he was a crack shot from any part of the room. It was like being

hit with a rock. By today's standards this all sounds pretty rough, but at the time it seemed perfectly normal. I have three kids, and, frankly, I'm in favor of strong discipline in the classroom.

Since Xavier was a Catholic school, we were closed on Columbus Day and St. Patrick's Day so the whole school—about a thousand kids—could march in the parades. ROTC was mandatory, so I spent four years commuting on the F train in uniform.

The one woman in the school was Miss Salvati, the librarian. She stood about four feet tall, and since she had the only set of breasts in the entire place, most of us stayed awake during Library Science. Even though it was an all-boys school, we had dances three or four times a year. Every fall there was a big military ball at some New York hotel. That's where I took my first date, a girl I knew from grade school.

I had an English teacher, Father O'Donovan, who encouraged me to write, and I published some drawings in the school magazine. In my senior year I became art editor, and before graduation the staff was treated to a Broadway show, *My Fair Lady*. I also remember seeing Alan Arkin in Carl Reiner's *Enter Laughing*. And, yeah, I even spent some time at the Museum of Modern Art.

Drawings by Jack for *Xavier,* his high school magazine. The one at the upper left is a self-portrait in school uniform.

THE COMICS: BOOKS, FILMS, STRIPS, AND GAGS

"Cartoon" is a portmanteau word that can mean anything from cereal box hucksters like Cap'n Crunch to graphic narratives such as Art Spiegelman's Pulitzer Prize–winning *Maus*. In between are comic strips, comic books, animated films, editorial cartoons, and the single-panel humorous drawings produced by Jack Ziegler and his compatriots for magazines like *Playboy* and *The New Yorker*.

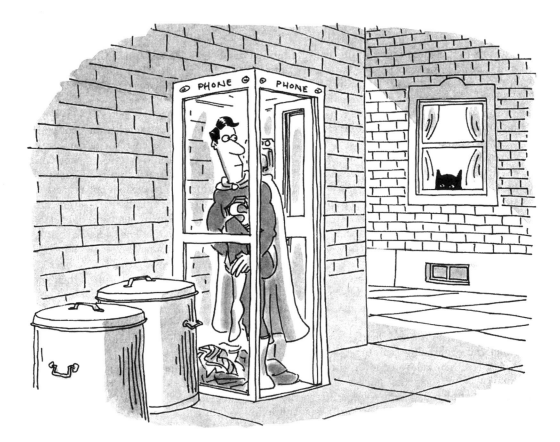

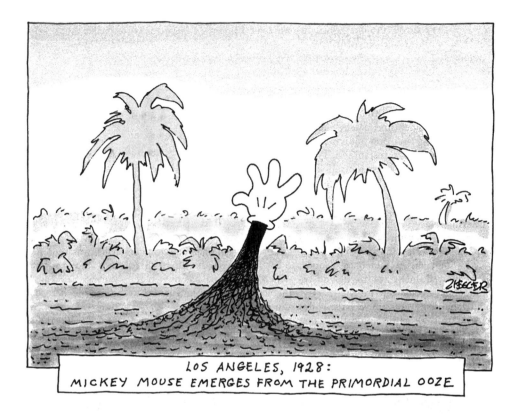

LOS ANGELES, 1928:
MICKEY MOUSE EMERGES FROM THE PRIMORDIAL OOZE

Much of this material is produced in assembly-line fashion. Comic books, and most comic strips, are written by one person, sketched in pencil by a second person, and inked in by a third. Lettering the headings and balloons is also the work of specialists, as is adding color. The production of animated films requires whole platoons of talented people—character designers, background artists, special effects experts, and the like, on down to the lowly serfs who painstakingly ink in the individual cells. The manpower and organizational skills required for something like Disney's *Prince of Egypt* is on the order of raising the great pyramids themselves.

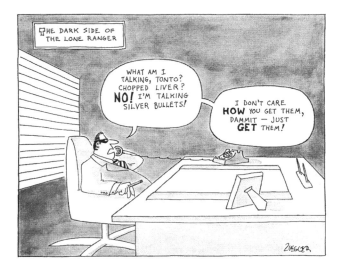

REFERENCE POINTS

Allusions to comic strips abound in Jack's work. Buck Rogers and the Lone Ranger seem to be particular favorites and are often transposed from the fantastic to the quotidian.

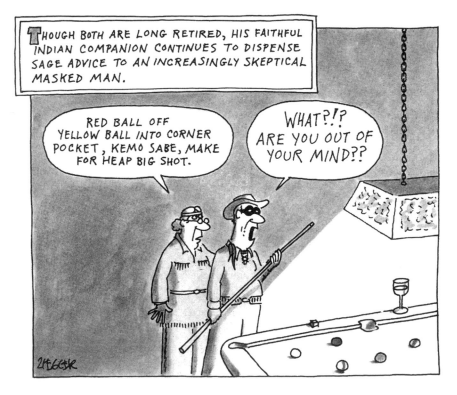

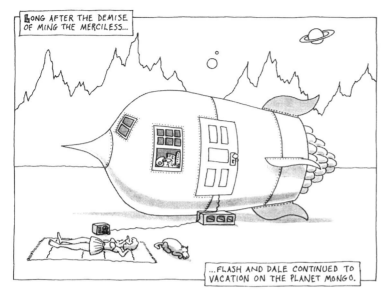

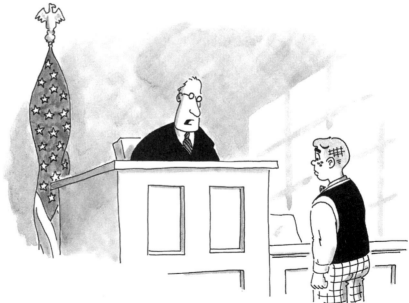

"Jughead, Reggie, Betty, and Veronica—they've all been locked up.
But you, Archie—I had higher hopes for you."

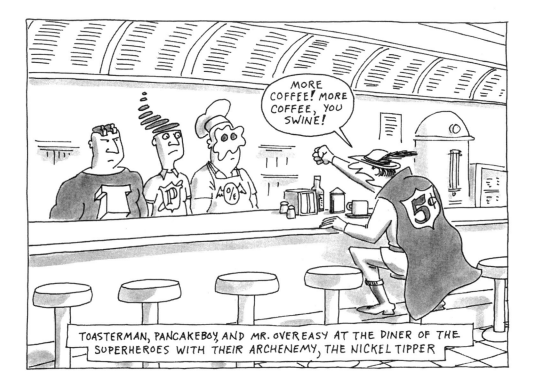

TOASTERMAN, PANCAKEBOY, AND MR. OVER EASY AT THE DINER OF THE SUPERHEROES WITH THEIR ARCHENEMY, THE NICKEL TIPPER

It comes as a surprise to many people, even some cartoonists, to learn that gag cartooning in its earliest years was also a collaborative effort. When *The New Yorker* was launched in 1925, most of the comic drawings that appeared on its pages, and those of its rivals, were drawn to order from ideas either purchased from writers or created by members of the editorial staff. The distinctive comic worlds of artists such as George Price, Helen Hokinson, and Peter Arno were almost entirely based on gags created by other people. Up to the 1950s, it was possible to make a living as a supplier of cartoon ideas, selling either directly to the artists or, in the case of *The New Yorker*, to the magazine.

LEE: You mentioned *Weird Science* and some other EC comics. Were those your favorites as a kid?

JACK: Yes, I liked the science fiction comics—*Weird Fantasy* was another, and the ones Harvey Kurtzman wrote for EC. He did *Frontline Combat, Two-Fisted Tales,* and eventually *MAD* comics, although I lost interest when *MAD* went to a magazine format in 1955.

LEE: So, except for *MAD,* these were not humorous strips.

JACK: No, I was more into serious stuff. Whenever I would draw, it would always be serious. I would draw war scenes. You know, soldiers, whatever a kid draws.

LEE: What about comic strips in the newspapers?

JACK: Oh, I liked *Dick Tracy* and *Moon Mullins,* and eventually there was *Dondi.* I'm not quite sure I read *Dondi,* but it was the first new strip that came along when I was, you know, there for its inception. I remember it as being a big event. Then I liked the Mary Perkins strip, *On Stage.* But only because it was so well drawn, by this guy Leonard Starr. I always thought the guys who drew this stuff also wrote it. Especially the comic books. Of course, that was totally wrong.

LEE: Were you funny as a kid?

JACK: I don't think so. I was kind of quiet—shy, really.

LEE: Did you make up any strips of your own?

JACK: Not really. Becoming a cartoonist never occurred to me. I was more interested in just drawing. The only cartoon I ever did, before I decided to become a cartoonist, was one that ran in my high school magazine when I was a freshman.

LEE: What was the strip called?

JACK: Oh, it wasn't a strip. I just did one single-panel cartoon. That was my first published sketch, but the only cartoon I ever did for them. I also did illustrations for short stories written by other students.

LEE: By the time you were in high school, were you interested in gag cartooning—single-panel cartoons?

JACK: No, not at all, but I enjoyed looking at them. I used to read *The New Yorker* and *The Saturday Evening Post,* and my parents had a subscription to *Look* magazine. I always loved the cartoons; sometimes I would cut them out and keep them. I used to save *New Yorker* covers back then, too, but it never occurred to me actually to do anything like that on my own.

LEE: Were you doing color work then?

JACK: No, I was just drawing, mostly with a fountain pen. Most of the old drawings are in blue ink on notebook paper.

LEE: You didn't take any drawing courses in high school?

JACK: Well, there weren't any. I went to a Jesuit high school. They would rather have you learn Latin and Greek than anything useful like drawing or music.

LEE: Did you do any writing while you were in high school?

JACK: I think I wrote one short story that appeared in that high school magazine. When I went to college, I sort of wanted to do something with art or writing. My parents weren't too happy with that. My mother wanted me to be an engineer, as I recall.

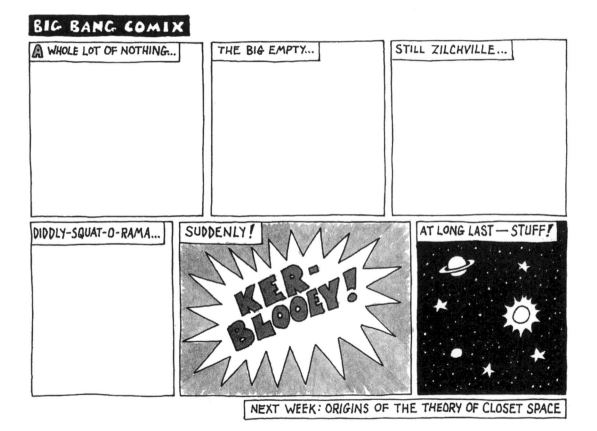

TWO ON A TOMBSTONE

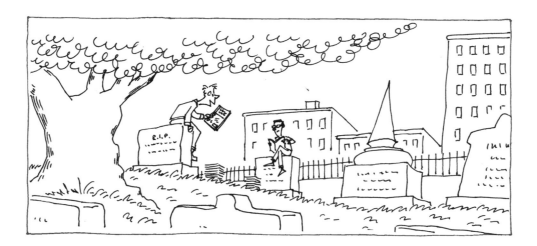

Every kid has a best pal. The one person who understands all your jokes, who appreciates your profound insights into the universe and can be trusted with your deepest secrets. For Jack Ziegler that special person was Brian McConnachie, a classmate at Our Lady Queen of Martyrs.

For most of us, these friendships fade over the years. Families move; interests change; out go the baseball cards, in come the girls. By adulthood most childhood friendships are reduced to a few scribbled lines inside the obligatory Christmas card. Jack and Brian are notable exceptions to this rule. Since childhood, when they met regularly in a quiet corner of a nearby cemetery to swap comic books, their lives have continued to orbit each other, intersecting at critical points. After college, they roomed together in Manhattan. Jack was best man at Brian's wedding, and there he met his first wife. Subsequently, Brian was the best man at Jack's wedding. It was Brian

who encouraged Jack to try his hand at cartooning, and it was Brian who made it possible for him to move back east by arranging to make his mother's summer house available. Jack and Brian did work for *National Lampoon* at the same time—Brian as a writer and editor, Jack as a lowly contributor—and they have collaborated on two books for children. Close as they are, however, a recent conversation with Brian suggests a young Jack Ziegler rather more adventurous than the introspective youngster the artist himself recalls:

"If Jack says he was shy, I guess he was shy, but I remember him as kind of a leader. He turned everyone on to *MAD* comics. He was the first one to discover Charles Addams, and he was digging rock and roll when everyone else was still 'singing along with Mitch.' It was Jack who organized our secret trips into the city. We used to comb through the used magazine stores around Times Square for back issues of our favorite comic books. If our parents had found out, they would have killed us. He even called up EC Publications and talked them into letting us drop by. We met the publishers, Bill Gaines and Al Feldstein, and a few of the artists—I think Wally Wood was one of them. They were very nice to us, especially when you consider we were only about twelve years old at the time.

"Jack was very determined. It was his idea to check out the phone book to see if any of the artists we liked lived in Queens. I think we visited Basil Wolverton, who did *Powerhouse Pepper,* and maybe Bernie Krigstein. And it was also Jack who said we ought to create our own comic book. We called it *Private* because we were the only two people on earth who ever got to look at this thing. He might not remember it—we never got any further than the cover."

COLLEGE YEARS

LEE: Where did you go to college?

JACK: Fordham. As a sort of compromise with my parents, I took a course in communication arts.

LEE: What are communication arts?

JACK: Beats me. Actually, the year I took it was the first year they offered it at the school. It was journalism, including writing newcasts for radio and television. Writing short plays. That sort of stuff.

LEE: Did Fordham have its own campus radio station?

JACK: Yes, but none of our stuff got on the air. It wasn't really meant to be on the air. These were just assignments, writing in all the forms of media. Another student and I once did an hour-long radio documentary, complete with sound bites on a subject that was totally made up. The professor was not thrilled.

LEE: And over that time you decided you were going to pursue writing?

JACK: I was going to try to do something in television. That's what I thought, anyway.

Self-portraits from Jack's sketchbook:
East Coast intensity and . . .

LEE: Did you do any writing on your own while you were at Fordham?

JACK: No, I didn't have time. I worked at CBS after class. I was a page there, basically an usher for all the shows that were in New York at the time. Ed Sullivan, Jackie Gleason, Garry Moore, and all the quiz shows, like *College Bowl*.

LEE: That was your extracurricular activity?

JACK: That was basically how I paid the nut. I would take the subway from school back down to the city to what's now the Ed Sullivan Theater on Broadway and go there and hang out. If I had schoolwork to do, I would do it there. Then I would work until 10 o'clock or so. I was working the Sullivan show the night the Beatles invaded America. That was the night "the sixties" officially began. They did two tapings before the live show, so they were in a pretty good groove by broadcast time. The audience, of course, went berserk. Oddly enough, I was also at the Rolling Stones' debacle five years later at Altamont, where the decade came to a resounding conclusion after dubious "security" provided by the Hell's Angels led to the death of an eighteen-year-old black man.

LEE: How did you get the CBS job?

JACK: It was posted on the bulletin board at school in, whatever they call it, the job center.

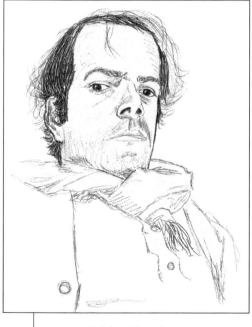

. . . Californial cool.

17

I went down and was interviewed by a guy named Randy Hill, who was the head of the pages. And he hired me. There were several other Fordham guys at CBS, too.

I did that all through the rest of college, from the beginning of my sophomore year through graduation. It was always more interesting to go down to CBS because a lot of the other pages were aspiring writers and actors, you know, taking the job just to make ends meet. They were so much more fun than the students at school. I'm still in touch with a couple of people I met there.

I SPY

LEE: And when you graduated you were thinking of writing for television . . .

JACK: Yeah, I was thinking that. I got a job at a place called D'Arcy Advertising, which is now D'Arcy, Masius, Benton & Bowles. I got a job in the mailroom. I worked there for almost a year, until I was about to get drafted, toward the end of 1965.

LEE: That was during the Vietnam War?

JACK: Yes. It was a frantic scramble to find a reserve unit, so I wouldn't be just a regular soldier and get sent over to Vietnam to get shot in a war that I didn't agree with. The unit I found involved taking a year of Russian at the Defense Language Institute in Monterey, California, so I did basic at Fort Dix and a year at the Presidio, where DLI was located. Six hours of Russian a day for an entire year. I was fairly good at it then, but now I get it mixed up with the German I took in high school. I was supposed to go on to Fort Holabird, Maryland, to learn how to be a spy. That was to be a four-month course.

LEE: Who were you going to spy on?

JACK: I have no idea. You just learn the basics of spying. But by the time I got out of the Presidio they had canceled the Fort Holabird thing. I was released to a reserve unit in the Bronx, and that's where I did my time.

LEE: Did you have a chance to do any writing or drawing?

JACK: Well, I used to write songs. I don't know how to write music, so I would use existing tunes and make up words to them.

LEE: Satiric songs?

JACK: Some of them were satiric. Most of them were just lonely soldier songs.

LEE: All this time, were you still thinking of writing for television?

JACK: Well, I was thinking more in terms of serious novel-type writing.

LEE: Did you take any notes while you were in the service?

JACK: No, but I used to keep a journal. Actually, I started it before I went in.

LEE: You did? Did you start it when you were in high school?

JACK: No, I began to keep a journal when I started working at D'Arcy. Then I continued it on a little bit into the service, but I didn't really have time for it in Monterey. I picked it up again a little bit afterwards.

LEE: Do you still keep a journal today?

JACK: No. One day I just stopped.

BALLAD FOR THE DEAD

(Dedicated to those who have forgotten how to live and enjoy. Ballad.)

I

When you hear someone callin'
You just turn away and stare
Down the alleys of the mindless
And the dark descending stairs
Into the hidden fortress
Where no one knows your deeds
Except the other weary ones
Who've taken the same creed.

II

You haven't felt the sun rise
Or felt a breath of air
You don't know what your heart is
Or if it's even there
You'll sit under the sidewalk
With a jug of wine
Satisfied to take your picture
Beneath a billboard sign.

III

The birds are flying south again
The tides are rolling out
The leaves are all upon the ground
But still you won't come out
The snow drift's at your window
As it's been for years
You still don't see the truth of it
There is someone who cares.

IV

There's been too many centuries
To let this one slip by
Without knowing with the finger
And grasping with the eye
So many years have come and gone
It nears the end of spring
Fall is here before you've moved—
One more tragic ending.

THE CHARLIE CADLEY DISLOCATION BLUES

While bounding from his home one day
Somewhere out round Brooklyn way
His thoughts were filled with net trans fax
And so the ice slammed him on his back.

His wife ran out from the sitting room
She said, Chargin' Chuck you've sealed your doom
He said, No sweat, love, it's just a scratch
And by the way do you have a match?

I'll smoke this butt while I'm lyin' here
Awaiting some doctors to appear
Bring out some cigars and a pint of rye
And stop your starin' and askin' why.

Some hospital people that happened round
And saw ol' Chuck upon the ground
Ran up to him in fits of glee
Askin', where's it hurt, man, yer hand or knee?

Unhand me now, you steaming nits,
Screamed Chargin' Chuck in starts & fits,
Will you let a man please drink in peace
And from this foolishness right now cease!

It's just our job, begged Dr. Bill,
So shut yer yap an' take these pills
They're red and white and blue throughout
So stuff them in, you goddamned lout.

They dragged him off then in a huff
Using leg-irons and handcuffs
But good ol' Charles had the last words:
"You freaking commie faggot turds!"

They say that Chuck's in Bellevue now
And all he drinks now comes from cows
But knowing Chuck, I doubt that tale
He gets it powdered through the mail.

—Charlie Cadley was Jack's superior at CBS Network
 Transmission Facilities in 1968–69. He had an
 accident on his way to work one day.

EXCERPT FROM THE 'FRISCO JOURNAL

I was in the package goods store down at the corner to pick up some Budweiser for dinner, and there was only one other customer in the store besides myself. He was about 45 years old and wore his trousers high and with large pleats. His shirt was one of those lightweight Dacron affairs that can be rinsed out in a motel sink and hung to dry and dewrinkle itself overnight on the shower curtain rod. His purchases included a box of Ritz crackers, a jar of Cheese Whiz and a half-pint of Seagram's 7, the total of which came to $3.10. He paid and left. I figured him for a traveling salesman, new in town, settling in for an evening of TV and a small high, because the store was in fact located on what is known as Motel Row. My six-pack cost me $1.32 and I figured I had the better deal. As I was paying the cashier, the Dacron man came in again mumbling, "Forgot something," and dashed into the rear of the store. In a couple of seconds he was back again, holding aloft a small plastic knife.

"How much for this?"

"Dime," said the cashier, scratching himself.

"For the cheese," said the Dacron man almost apologetically as he handed over his money and left once again.

So, I concluded, he's a salesman and a lover, too. Hah!

But the cashier flatly refused to exchange any knowing glances with me.

4/11/69

BACK IN CIVVIES

JACK: In 1967, when I finally got out of the service, I landed a job with CBS radio—a night job. I would go in at three in the afternoon and get out at eleven or so. That was for the CBS Radio Network, and I can barely remember what I did. It was something about scheduling. I used to see Frank Gifford and Walter Cronkite all the time, stalking each other through the darkened halls. After that, I got a job over at the TV network in Network Transmission Facilities, or Net Trans Fax. It was sort of a technical job of setting up different affiliates to carry NFL games to the proper sections of the country and other networks to carry regional commercials—for example, making sure that some places got commercials for Exxon and other parts got commercials for Esso, before the whole country switched to Exxon. The only good thing about that job was that I had the greatest phone number in the world. It was 765-4321, extension 2020. Another network eventually named a TV show after my extension. It was my greatest achievement in show business.

LEE: Were you still living at home at this point?

JACK: No, I had an apartment in the city. I shared it with Brian McConnachie until he got married. Then I got a place of my own in the same building. And then *I* got married, so I was back sharing an apartment again—with a wife.

LEE: Were you doing any writing while you were enjoying single life in Manhattan?

JACK: No, but I was still drawing.

LEE: Did you ever draw from life?

JACK: I used to occasionally draw people, but most of the time I was just making up stuff. I didn't do it a lot—not every night or anything like that.

LEE: It never occurred to you to take any drawing courses?

JACK: No, my parents were very down on that when I was in college. They felt there was no possible way to earn a living by doing anything like that, and I guess I sort of listened to them.

LEE: So your creative ambitions were limited to writing.

JACK: At that point, yeah. Then, in 1968, I got married, and my wife and I lived in New York. It was a whirlwind courtship. About six or eight months after I met Jean Ann at Brian's wedding, we got married and lived in my apartment on Fifty-Fifth Street between Eighth and Ninth Avenues. An interesting sidebar: when we moved out of that apartment, future horror/sci-fi writer Whitley Strieber took over our lease. I think he was in advertising back then.

In one of his later books, he claimed to have been visited by aliens in that very same apartment. Apparently, we got out just in time.

LEE: Was your wife working?

JACK: Yes, she had a teaching job at a Catholic grade school. We stayed in New York for about a year and then decided we didn't want to stay there anymore. I kind of wanted to go back to California, and she was game to do it. So, in early '69, we bought a Volkswagen bus, packed it full of whatever we had at that point—which wasn't much—and drove to San Francisco.

We rented an apartment in the Marina district. They didn't allow pets, but within two weeks we bought a German shepherd puppy on the street for $25. A couple of weeks after that, she was too big for us to sneak her in and out under our coats, so we had to move out. We found a floor-through near Fisherman's Wharf. Then, when Jean Ann got pregnant, we moved *again*, this time to a dreary but cheap place in the Mission district. When we started hearing rats scampering through the walls, we moved one final time to an apartment on

Stanyan Street across from Golden Gate Park. It was a great apartment except for the derelicts who would attempt to steal anything we left in our VW bus, which had to be parked on the street. It sounds like we did nothing but load and unload the van, but actually we dug San Francisco. I hung out at the City Lights bookstore, sort of the capital of the beat scene out there. It was also a great spot to find old cartoon books. The underground cartoon thing was getting some attention. I liked some of it, especially R. Crumb, but I was really more interested in the music scene. There was a great rock-and-roll club in the Marina called The Matrix, and we spent a lot of time there. The Joy of Cooking came through, and Quicksilver Messenger Service. Once Lou Reed and The Velvet Underground had a weeklong gig there. I used to see them back in New York at a place on the Upper East Side called the Gymnasium, along with Andy Warhol's Exploding Plastic Inevitable. Well, in those days in San Francisco, people were a little closed-minded to out-of-town bands. I went the first night, and the place was fairly full. I went two more times, and by the last night it was just me and some other guy enjoying the band. I have to say they did two perfect sets anyway.

ANYTHING'S BETTER THAN WAGES

LEE: In San Francisco you seemed to be getting further away from cartooning, not closer.

JACK: Well, how I finally got into cartooning is pretty strange. I had drawn since I was a kid, and I sort of had ambitions to be a writer, but it never occurred to me to put them together. After we moved to California, Jean Ann was teaching but I wasn't doing much of anything. Each job I took seemed

to be worse than the previous one. At one point, I was doing surveys for a local TV station, KTVU in Oakland, like "Are you enjoying the reruns of *The Flying Nun?*"

One night I got completely blotto and declared that I was never going to hold a salaried job again. Jean Ann, who was pregnant at the time, became hysterical—and rightly so. The next day I started writing a novel. My idea was to tell the whole history of the sixties as if it had happened in one week. I called it *Last Kansas,* which was meant in some way to connect it to *The Wizard of Oz.* I spent six months on it and then read it back slowly when I was finished. It was terrible. I sent it to a few agents, and they thought it was terrible, too. Six months down the toilet. In desperation, I was about to

start another one when I got a card from Brian McConnachie. He was also trying to be a writer, but he was actually selling stuff. He said he had made a connection at *National Lampoon* in New York. He had sold a few pieces, and now they were asking him to do cartoons. The thing was, Brian couldn't draw. He knew I could, so he suggested that we collaborate: "You draw and I'll write. We'll sell thousands of cartoons, make a ton of money, and retire young." Jean Ann and I talked it over, and we agreed we had nothing to lose. God knows, nothing else was happening.

In the fall of 1972 we (wife, daughter and dog) moved back east to be closer to the vast

Jack's personal postcard in color,
announcing his change of address.

publishing empires of New York. Brian's mom had a summer place on Long Island. We lived there through a very cold winter and then found a cheap apartment in New Haven, Connecticut. I bought a Rapidograph pen and a few reams of typing paper and set up a studio for myself in one corner of the bedroom. I tried working with Brian, but right away I realized I wanted to draw my ideas, not his. Even so, Brian introduced me to the gang at the *Lampoon,* and I also began meeting other cartoonists, making the rounds of the magazines on Wednesdays. Everybody was encouraging, but I wasn't selling anything. The train I took from New Haven passed all those old factories in Bridgeport, and I was sure I was going to end up working in one of them.

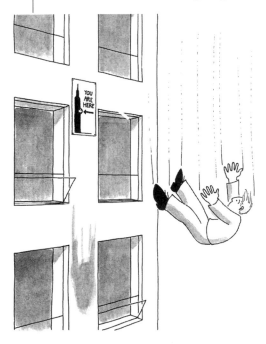

Jack's first cartoon in the *Lampoon,* April 1974.

I got some good advice from the cartoonists I met—Henry Martin, Sid Harris, and Bill Woodman—and Doug Kenney at the *Lampoon* was very helpful. Still, I think I did five hundred drawings before I began to get the hang of it, and another thousand or two before I liked what I saw. Finally, I made my first sale— *True Detective,* twenty bucks. My second year I made a fat hundred bucks. I had inherited ten thousand bucks when my father died, so we had a little something to live on.

Then, in '73, things started to click. I began to sell regularly to *The Saturday Review, Cosmopolitan,* and *Writer's Digest.*

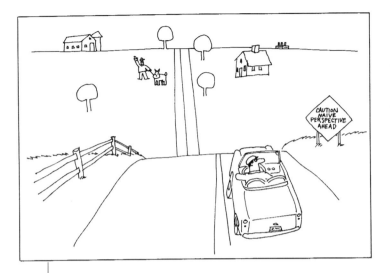

A couple of years later, one of my biggest markets was *Esquire*. Harvey Kurtzman, the same Harvey Kurtzman who had started the *MAD* comics that I had loved as a kid, became cartoon editor there, and he was nuts about my stuff. He bought so many cartoons that he farmed out some of my ideas to other artists.

Esquire was featuring color work at that time, and Harvey kept trying to get me to do color finishes. My color was lousy, but Harvey was amazingly patient. I would get OKs from him with extremely detailed instructions. He even supplied color samples on a transparent overlay. When he finally realized I still wasn't getting it, he invited me out to his house for a sort of private tutorial. We spent a whole day together. He covered everything from arranging the paint on a palette to color theory. Besides being a great cartoonist, Harvey was the sweetest guy in the whole world.

LEE: I'm sure you began to meet some of the other artists when you were making the rounds.

JACK: The first one I met was probably Henry Martin over at *True Magazine*. Then I met Sam Gross, because there's no way you can't meet Sam. I also hung out with the gang at *National Lampoon*.

Below and on the facing page are samples of the generous editorial guidance that Harvey Kurtzman offered to Jack. Kurtzman would later recall Jack and the *Esquire* years this way: "The best part of the job was opening the mail. Some of it was like opening a box of candy. But Jack was my absolute favorite because he could always be counted on for a surprise. It was as if he was inventing new forms. There are really very few gag cartoonists who use forms for their cartoons that are unique."

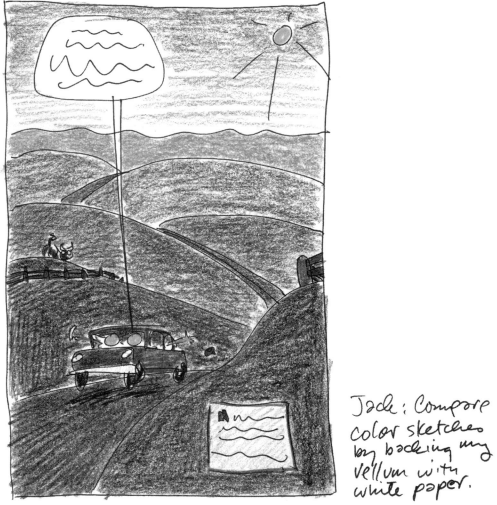

Jack: Compare color sketches by backing my vellum with white paper.

What I've done is to suggest that you organise color so that important elements (3 figures) are warmest color spots while background recedes. Warm comes forward. Cool recedes.

Ballerina is white with touches of yellow.

Man is hot orange red

Kid is red.

Man silhouettes against darker brown. Girl against darker blue. Walls aren't intense ~~in~~ pigments, but figures are.

Although Jack Ziegler is firmly established as a *New Yorker* cartoonist, the publications that bracket his formative years are *MAD* comics, which he read as a child, and twenty years later *National Lampoon*. Jack's contributions to the *Lampoon* were neither abundant nor memorable, but the editorial suggestions, the encouragement, and most of all the camaraderie played a pivotal role in his decision to pursue a career in cartooning:

"When I was starting out, Doug Kenney, one of the editors, was a big help to me. I don't think he ever had any art training, but his suggestions were always right on the money. The *Lampoon* offices were on Madison Avenue near Fifty-Ninth Street, and I used to drop by there after the Wednesday rounds. There was a saloon just around the corner. The whole gang would gather there late in the day and talk about the magazine. It was sort of an editorial meeting with an open bar. Henry Beard, Doug Kenney, and Michael O'Donoghue were always there. Sometimes, George Trow from *The New Yorker* showed up. Anne Beatts, the only woman writing for them at that time, was usually there, and, of course, Brian McConnachie. They tossed around ideas for parodies and satire. They improvised poetry and songs on the spot. They imagined

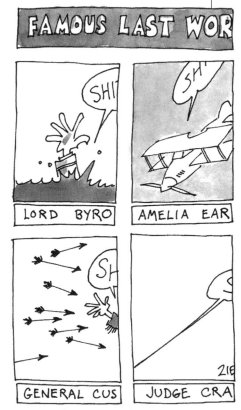

Drawing from *National Lampoon*, 1984.

entire future issues. That's where Brian came up with his politically incorrect 'Anthems of Emerging Nations,' a collection of anthems for newly renamed countries, real and imaginary. I always left convinced they were the smartest, funniest people in the world, but the next day I couldn't remember a single word anyone said. I don't think anyone else could either, because the ideas generated at these liquid sessions rarely, if ever, saw the light of print."

"N-n-n-n-n-nude D-d-d-d-descending a St-st-st-st-st-st-st-st-st-st-"

From *Artist Magazine,* 1984.

National Lampoon was, of course, a spin-off of the widely admired Harvard humor magazine, *The Harvard Lampoon.* In the sixties a talented group of undergrads inspired by such New Wave comics as Mort Sahl, Lenny Bruce, Jules Feiffer, and Nichols and May seized editorial control. The traditional white-glove humor was replaced by sharp-edged satire—topical, irreverent, and often ironic. Issue-length parodies of *Mademoiselle, Time,* and eventually *Playboy* created an audience beyond Harvard Square. In 1970 a trio of recent graduates, including Beard and Kenney, launched *National Lampoon* with the backing of 21st Century Publishing (which owned *Weight Watchers*). After a rocky beginning, the magazine prospered. By the end of its second year it was both a financial and an artistic success.

Inevitably, the *Lampoon* covered much of the ground already tilled by *MAD Magazine,* but the differences in style were profound. *MAD* promoted itself as "humor in a jugular vein" and struggled to live up to its masthead.

Jack's contribution to the annual poster printed by cartoonists' agent Herb Valen, spring 1990.

With zany graphics and pie-in-the-face parodies, it radiated an irresistible air of adolescent mayhem. By contrast, the *Lampoon*'s satire was intentionally dead-pan and subtle—often barely distinguishable from the real thing. The graphics were illustrative, not parodic, and the prose more consciously "sophisticated." In today's jargon, *National Lampoon* was text-driven and *MAD Magazine* was art-driven. *MAD* was (and still is) for kids. The *Lampoon* wasn't.

Ironically, in our post-literate age the *Lampoon* survives only as the manufacturer of sadly unfunny film vehicles for Chevy Chase, while the appeal of the broadly comic *MAD Magazine* remains undiminished.

LEE: In addition to your weekly trips to the city, were you doing a lot of mailing?

JACK: The reformatted, resurrected *Saturday Evening Post* was a mailing, as was *Writer's Digest*. I used to send stuff to *Playboy*, but I never sold anything to them until about fifteen years after I'd been with *The New Yorker*. There was another magazine I sold stuff to. It was *Playgirl*, sort of a *Playboy* for women, and a couple of girlie magazines, *Genesis* and *Cavalier*.

From the *New York Times Book Review,* June 3, 1984.

"Puerto San Miguel—July, August, September, October 1983: I must finally confess that my Scandinavian trilogy is not going well . . ."

FAMOUS WRITERS' TV SPINOFFS

| From *Writer's Digest*

JERZY KOMATOSE
WEEKDAYS, 11:00 P.M.

A young orphan walks across war-torn Europe, befriending celebrities and chatting them into a state of stupefaction.

ERMA BOMBSQUAD
TUESDAYS, 8:30 P.M.

Overcome by suburban malaise, our heroine takes a job with a specialized unit of the Larchmont Police Department.

ANDY LOONEY TUNES
SUNDAYS, 9:57 A.M.

Andy ponders such mysteries as these: Why do talking animals talk so much? Why don't they have jobs like you and I? And how come Daffy Duck never got old and died?

SHEL SILVERFISH
WEEKDAYS, 2:00 P.M.

The well-known poet of the drainpipe spouts forth in verse on everything from clogged sinks to the advanced sewage treatment facilities at Utica, New York.

HELEN GIRLY-BOY
THURSDAYS, 3:30 P.M.

Mrs. Girly-Boy edits a big, fat metropolitan magazine and also dispenses advice on romance, skin-care, and Nietzschean philosophy to anyone within earshot.

KURT VON TWO TREE FOUR
DAILY, 3:59 A.M.

Hi ho. And so it goes. On and on. Ever anon. La di dah.

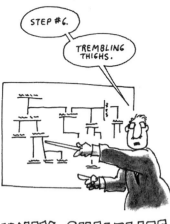

SIDNEY SHELFLIFE
MONDAYS, 9:15 P.M.

What ingredients does a novel need to make it last at least six months on the New York Times bestseller charts? Sidney explains in prose designed for the masses.

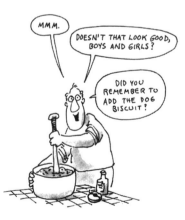

FRED MUSTARD MAYONNAISE
SATURDAYS, 10:30 A.M.

The stoveless school of cooking takes a great leap forward as Fred guides the kiddies through a series of recipes that only a mother could love.

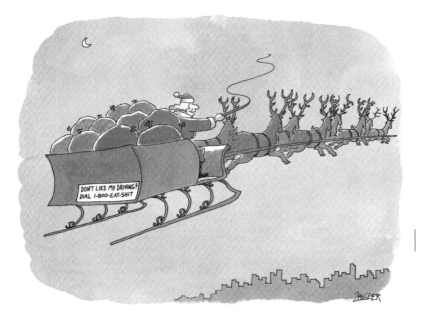

Drawing from *Playboy* magazine, January 1992.

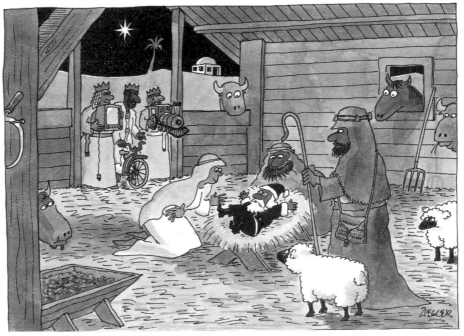

Full-color Christmas card sold commercially in 1993.

LEE: So when you began to sell on a more regular basis, did you look around for another place to live? Is that when you moved?

JACK: No, we stayed in New Haven until our daughter, Jessica, was old enough to go to school. We decided to look for a house then, but we had no idea where we wanted to live. I drew like a seventy-five-mile radius around New York City and just went looking on the edges. We looked out on Long Island and even in New Jersey, and then we discovered New Milford, Connecticut. Drove into the town and ended up on the green there and really liked the feel of it. Went to the first real estate place we could find and told them we wanted to buy a house but didn't have any money. They said that's no problem.

LEE: Boy, those were the days!

JACK: Of course, it *was* a problem. I guess they figured by the time we found a house we'd somehow come up with the money, so I wound up borrowing the down payment. The price of the house was $39,500, which nowadays seems like nothing, but we had no money at all back then.

LEE: By that time you had a contractual relationship with *The New Yorker.*

JACK: Right. That started in 1975. I had been submitting drawings since 1972 and went for a year without a nibble. Then, thank God, they started buying, and I was offered a contract a little over a year after that.

LEE: What kind of a work schedule did you have at that point?

JACK: By that time, we had a second child, Benjamin, and eventually there was a third, Max. I always wanted to take the weekends off, so I would try to

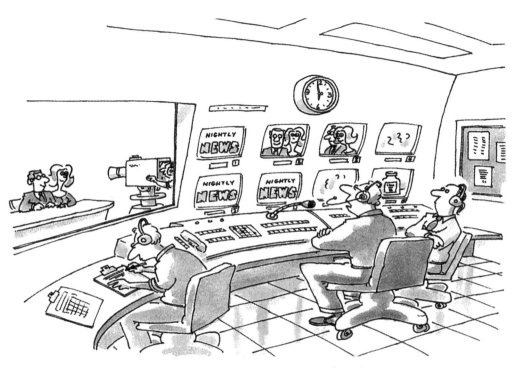

*"Pan down a bit, camera two, so that America
can get a gander at Wendy's bazookas."*

have as normal a schedule as possible for the kids as they were growing up. Basically, Monday through Friday I would start around 9 A.M. and try to be done by 6 P.M., unless there was some big pressing thing. I'm still the same way. I try to take weekends off.

LEE: So did you have a spare room that you could use as a studio? Or did you have a studio outside the house?

JACK: The New Milford house had a breezeway that connected to a garage, and at first I used the breezeway as my studio. But it only had screens and, come November, we didn't have any money to put in windows and insulation. I moved into the dining room, which was just a horrible nightmare for everybody concerned because it was such a small house.

"Oh, Margo, the pain! Will I ever get over losing you?
Probably not. But that's not why I called. Is that
hot-looking roommate of yours anywhere around?"

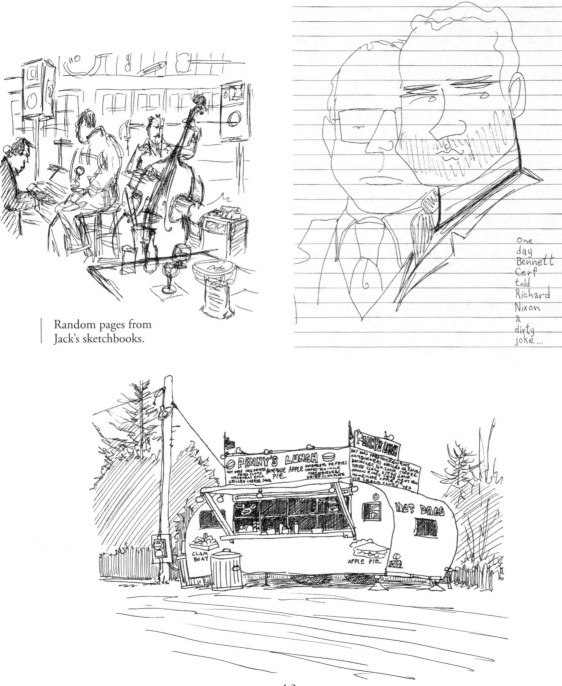

Random pages from
Jack's sketchbooks.

One
day
Bennett
Cerf
told
Richard
Nixon
a
dirty
joke...

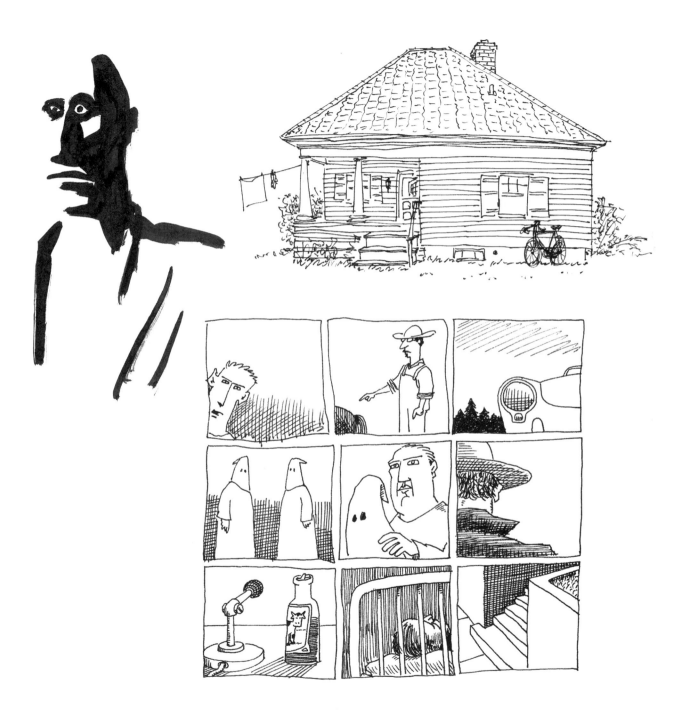

43

Jack's first drawing
for *The New Yorker*,
February 11, 1974.

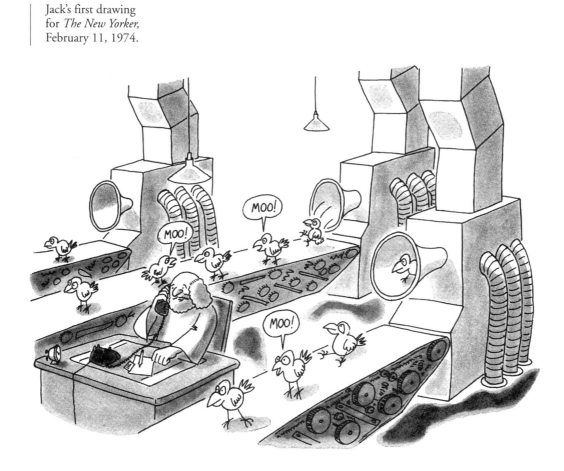

"Hello? Beasts of the Field? This is Lou, over in Birds of the Air.
Anything funny going on at your end?"

THE NEW YORKER

Unlike most magazines, *The New Yorker* does not have an open-door policy for cartoonists. Regulars are allowed to drop by on Tuesday, but unsolicited submissions must be either mailed in (with a stamped, self-addressed envelope) or dropped off at the sixteenth-floor desk. This policy has caused many cartoonists to grumble about the magazine's perceived aloofness. In fact, it would be impossible for an editor to meet with the creators of the two thousand-plus drawings that flow into the art department each week.

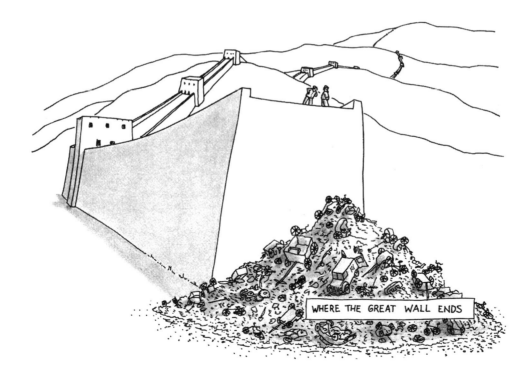

WHERE THE GREAT WALL ENDS

In 1972, when Jack began submitting, *The New Yorker*'s distinguished art editor, James Geraghty, was preparing to retire. Geraghty had joined the staff in 1939 as a gag writer and part-time cartoon editor. During World War II, he gradually assumed responsibility for all the magazine's art. In 1945 he was officially anointed art editor, while Rea Irvin, who had guided the magazine's art since its inception in 1925, was elevated to the largely honorary position of art director.

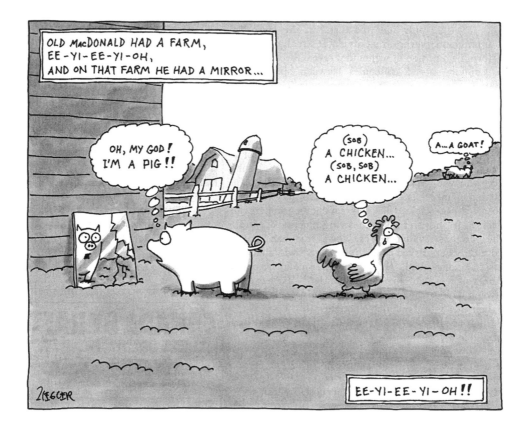

Geraghty had been recommended to Harold Ross, the magazine's founding editor, by Peter Arno, to whom he supplied numerous ideas for cartoons. Geraghty was as good at polishing other people's captions as he was at creating original ideas. Over his career, he (anonymously) wrote and rewrote hundreds of the magazine's best cartoons. Although he had no art training, Geraghty also proved to be an outstanding editor of the magazine's drawings and covers. His response was strictly intuitive, but artists as distinguished as Charles Addams, Ludwig Bemelmans, and Saul Steinberg all shared confidence in his judgment.

Working with established artists is the easiest part of the editor's job, however; discovering new artists is the most difficult. Over his career, Geraghty located and nourished a continuing flow of fresh talent. The postwar years produced Dana Fradon, Robert Kraus, Joe Mirachi, and Ed Fisher. In the fifties and sixties an even younger group swept in, including James Stevenson, Charles Saxon, Donald Reilly, George Booth, Ed Koren, Charles Barsotti, Bud Handelsman, and Robert Weber.

In 1958, when Jim Geraghty asked me to become a contract contributor to *The New Yorker*, my own ambitions as a cartoonist were satisfied. It never occurred to me that fifteen years later, after accepting Geraghty's retirement, William Shawn, the editor, would offer me the position of art editor. With considerable trepidation, I agreed in the summer of 1973 to "try out" for the job. This meant quietly observing Geraghty when he met with the regular contributors on Tuesday mornings, and joining him and Shawn in the afternoon when they met to buy drawings and OK fresh ideas. It also meant going through the "slush file," each week's accumulation of unsolicited contributions. The bulk of this material, about ninety percent, was clearly unpublishable. That left some two or three hundred drawings about evenly divided between established artists and talented newcomers. My responsibility was to fish out promising candidates and pass their work along to Geraghty.

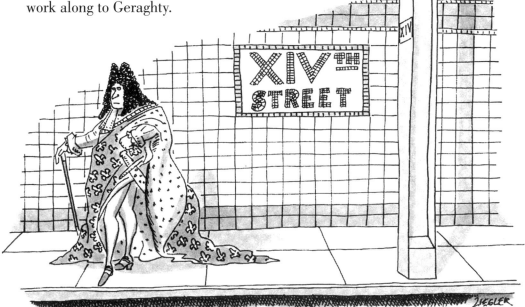

ENTER JACK—STAGE LEFT

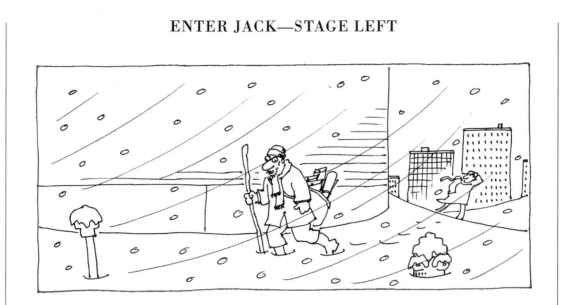

It was during one of these weekly trolling sessions that I first reeled in the drawings of Jack Ziegler. Perhaps "became aware of the drawings of Jack Ziegler" would be more accurate. Jack's arrival was not announced by a thunderclap. Then, as now, his work tended to sneak up on you. My initial response was puzzlement. Many of the cartoons had boxed headings rather than the traditional captions. There was an abundance of bad puns. The drawing was static; the ideas, inscrutable. The net effect was surreal. Jack aptly summarized my impression of this awkward early work when he said years later, "I enjoy drawings where nothing happens, and nothing *continues* to happen." His cartoons were like ideas still waiting to hatch. Interesting they certainly were, but were they funny? I showed a few to Geraghty, who felt they echoed, in a primitive way, work we were already receiving from Steinberg.

When I officially replaced Geraghty at the end of 1973, I began slipping selections of Jack's work into each week's art meeting. Shawn was intrigued, but not convinced. And then something happened, which I later experienced with other new contributors. Suddenly, the work became funnier! Either Jack was improving, or Shawn and I were beginning to "get it." We began buying —sporadically and then regularly. Soon Jack joined the artists I met with each week.

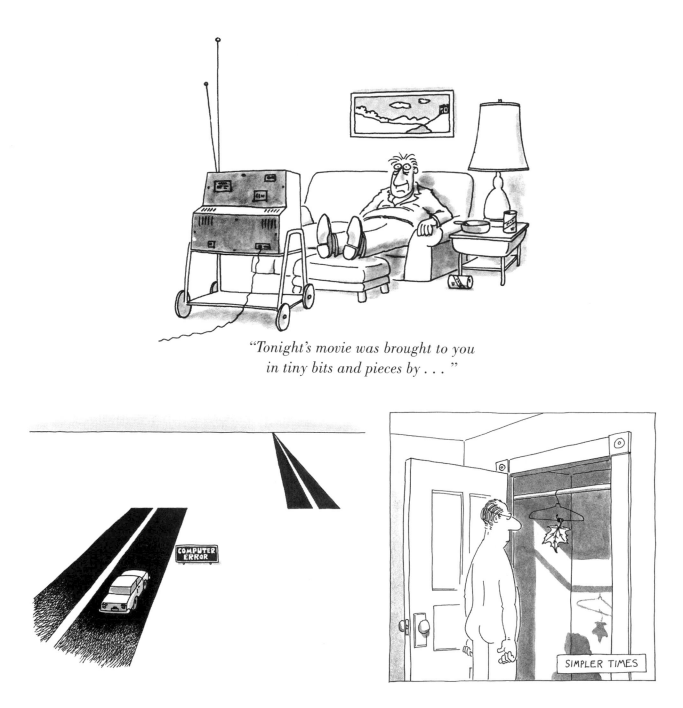

"Tonight's movie was brought to you
in tiny bits and pieces by . . ."

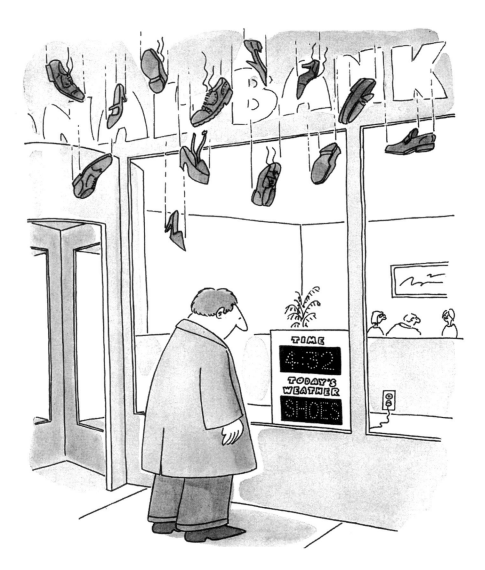

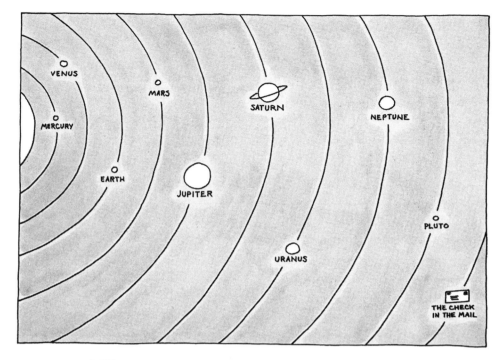

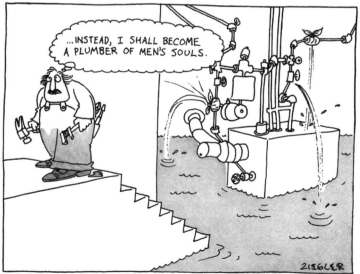

Inspiration

After a few meetings he asked, with characteristic politeness, when he might expect to see some of his drawings published in the magazine. A quick check revealed nearly a half-dozen drawings languishing in the magazine's inventory, or "bank." The bottleneck was soon located. The head of the makeup department, an independent-minded survivor of the magazine's earliest years, had unilaterally decided that Jack's work did not live up to the magazine's high standards. As quickly as the

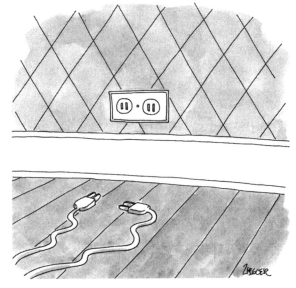

"The one on the left is cute."

cartoons were purchased, this gentleman, Carmine Peppe, hid them in the bottom of the least accessible drawer in the makeup department. Carmine was already famous for his volcanic temper and disdain for rank. (He derisively referred to James Geraghty as "Rembrandt.") Peppe had joined the staff in 1927, and the opinion of a newcomer like me carried no weight. Only after a direct appeal from Shawn did Jack's work begin appearing in the magazine. Peppe grimly continued to predict that Ziegler's presence would lead to an eventual decline in the magazine's standards. For Carmine, this prophecy was fulfilled when, in 1976, we began publishing the drawings of an even more controversial artist, Roz Chast.

FRIENDS AND INFLUENCES

LEE: When you started at *The New Yorker,* were you coming in on a weekly basis? Or every other week?

JACK: I was on a biweekly schedule when I first came in to see you. I would bring these double batches, thirty drawings or something, which seemed like a lot to look through. So I started coming in on a weekly basis.

LEE: Seems to me that was coming in on Wednesday. Who else was in the Wednesday bunch?

JACK: Henry Martin, Sam Gross, Bill Woodman, Roz Chast, Arnie Levin . . .

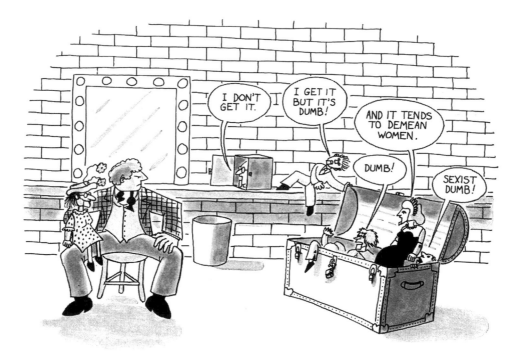

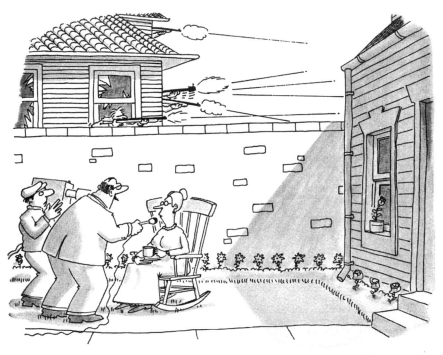

"They've always been such nice neighbors—friendly,
quiet. Up until today, of course."

LEE: Which cartoonists were your closest friends in those days?

JACK: At that point, I became very friendly with Roz Chast. John Caldwell was a good friend. I would occasionally run into Leo Cullum, who flew jets in from California. I hung out a lot with Bill Woodman. Later pals include Michael Maslin and Liza Donnelly, at whose nuptials I attempted to officiate but was, alas, rejected. I also became friends with Bob Mankoff, Mick Stevens, Dick Cline, and Sam Gross. Occasionally, a group of us would go out for lunch or drinks.

LEE: As you look back at your career, are there artists whom you particularly admire?

JACK: Yes, I would say George Booth, because both he and his work are just so funny. I really like funny cartoons. I like Dedini, although I don't see everything he does. The ones that are published are really good. I think Barsotti is very funny. I like a lot of Roz's stuff. Very neurotic, of course, but that's who she is. I always liked Bill Woodman's stuff. He used to keep all these sketchbooks—he was always drawing, and the stuff in the sketchbooks was just hilarious, but he never seemed to be able to translate that into cartoons that would sell, which was very mysterious to me. Bob Weber and Donald Reilly seem to be true artists who happen also to be cartoonists.

LEE: What about Robert Crumb?

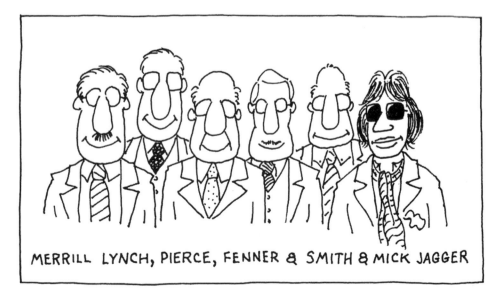

MERRILL LYNCH, PIERCE, FENNER & SMITH & MICK JAGGER

JACK: Well, I was influenced by Crumb when I started cartooning. I liked his drawings, although I couldn't draw that way. His stuff was pretty funny.

LEE: Were there other people in the underground comic world who interested you back then?

JACK: There were guys who did posters for places like the Avalon Ballroom in San Francisco that I really liked who were basically cartoonists. Rick Griffin, Victor Moscoso, Stanley Mouse, and Alton Kelley. I thought Kliban was very funny, maybe the funniest— and a huge influence on my entire outlook.

LEE: Did you know him at all?

JACK: I met him once, and I'm friends with his ex-wife, Mary K. Brown. I know her better than I ever knew him, and I always thought her cartoons were really funny and unique. She does gorgeous, bizarre paintings, too.

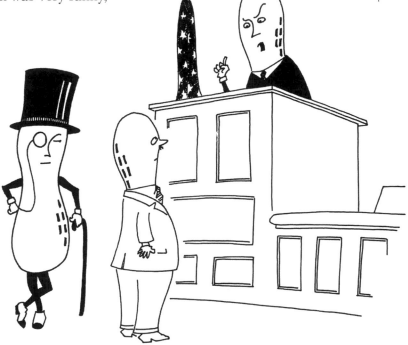

"Counsellor will instruct his client to remove his hat and put on some pants before sentencing."

Roz Chast

A Reminiscence

When I graduated from the Rhode Island School of Design in 1977, I thought I was going to be a regular kind of illustrator. I mean, I'd done all these weird drawings all through school, but I never thought anyone would buy them. I moved back in with my parents in Brooklyn and schlepped my illustration portfolio around to the magazines in Manhattan. I did manage to sell a few drawings—more like spots—rarely to *The Village Voice*. I think I sold something to *Christopher Street* too, for a fat ten bucks. I also tried places like *National Lampoon*.

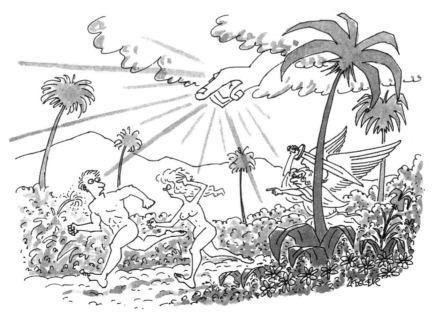

"At least we don't have to sit through some big, prolonged trial."

Eventually I began to meet some other artists, mainly at *The New Yorker*—Sam Gross, Bill Woodman, Dick Cline, and Bob Mankoff. They used to have lunch in strange little places around Midtown. Chili joints, Chinese restaurants—real oddball greasy spoons. I remember The Quiet Man, Tin Pan Alley, Kenny's Steak Pub, and Judy's. Judy's was a Judy Garland theme restaurant without a bathroom. You had to use the one in the hotel lobby next door. There were usually seven or eight of us. That's where I met Jack, he seemed to be the lunch meister. He was publishing regularly in *The New Yorker*, and everybody sort of looked up to him.

There were a lot of heavy talkers at these lunches, but Jack never said much. Compared to him, I'm Miss Blabby. He was a generous laugher, though, and somehow he set the pace. He and Brian McConnachie were always organizing little excursions. We took the Circle Line boat ride around Manhattan, and once we went to the horse races at Belmont. Gradually the lunch bunch shrank to pretty much me, Jack, Mick Stevens, Bob Mankoff, and often Liza Donnelly. It wasn't really cool to look at each other's roughs, but we sometimes passed around ideas that had been rejected. We sort of shared grievances. Jack was very helpful on the nuts-and-bolts side of the business. He's very well organized and he's a good judge of people; he always seemed to know how to handle situations. In his own quiet way, he's a natural leader.

After I began selling to *The New Yorker* in '79, I used to visit Jack in Connecticut. There was always some occasion for a party—and I loved his kids. The Zieglers' tailgate lunches at the Yale Bowl were sort of the social highlight of the cartoonist's year. And yeah, Jack is a great cartoonist.

Mick Stevens

A Thank-You

In 1979, I sold my first cartoon to *The New Yorker*. I promptly moved from San Francisco to Tribeca in Manhattan. It was six months before I sold my next one.

Even before I came back east, I had been in touch with Jack through the Cartoonist's Guild. I loved his stuff. He was the last artist I tried to imitate. (The first one was Mort Walker, who did *Beetle Bailey*.)

When I got to New York, I called Jack and invited myself out to meet him at his home in New Milford, Connecticut. He answered the door with a beer

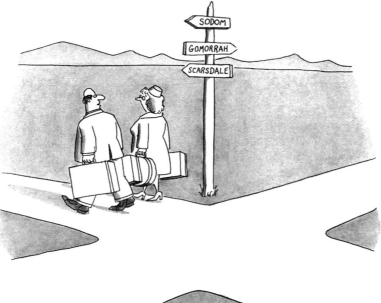

"Let's hope, Lucille, that our decision hasn't been too hasty."

in his hand. It was weird. We were both wearing jeans, sneakers, and beards. We were about the same height and age. I was like his doppelgänger. Then I found out we had both been in the service at about the same time and had landed in San Francisco at the same time. At that point, I decided to have a beer, too.

Jack looked at my stuff and was very encouraging. We started hanging out together on Wednesdays after the cartoonists' lunch in the city. I lived near a sort of artists' hangout called Magoo's, down on Sixth Avenue and Walker Street. It was a two-room joint, and the walls were decorated with paintings the owner had accepted to settle tabs. We'd spend the afternoon shooting pool and drinking beer. Bill Woodman was often with us, and we'd end the day with a nightcap at a bar near his place called The Balcony on the Upper West Side. Jack was always worried about my taking the subway back downtown at night. He'd say, "It's not safe— you better come with me." Who was I to argue? We'd drive in his van back to Connecticut. I'd spend the night, and sometimes the next night, too. Jean Ann, Jack's wife, was very sweet, but after all, she did have three small kids. Gradually, I cut my visits back to the weekends.

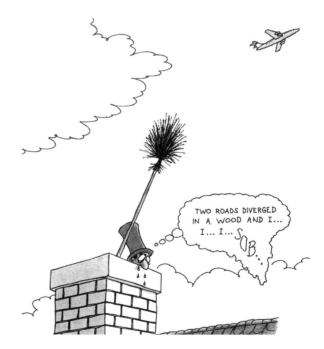

TWO ROADS DIVERGED
IN A WOOD AND I...
I... I... SOB.

I live up on Martha's Vineyard now, so I don't see Jack as much as I used to. We're still in touch, though. E-mail, mostly. Jack is not a phone person.

I guess he's like his work—nothing fancy, but what's there is always top-quality.

Bob Mankoff

An Appreciation

I first met Jack in *The New Yorker*'s offices in the late seventies. I had just begun to sell, and of course he was already a rising star. Even so, he was warm and friendly right off the bat. Wednesday was the day we all descended on the magazine, and I remember it as a time of high anxiety. Jack became part of a small lunch group that included Roz Chast, Bill Woodman, Mick

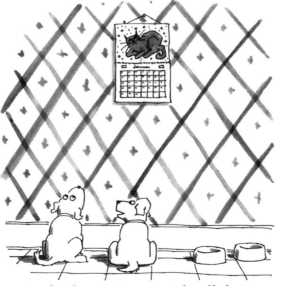

"It's a cat calendar, so it may not be all that accurate."

Stevens, and me. Sometimes we passed around our roughs, but more for sympathy than critiques. It was sort of our mutual support group.

When I started cartooning, I was inspired by two very different artists: Saul Steinberg, whose conceptual approach knocked me out, and Jack Ziegler because he combined so many elements in his work. Jack made it seem natural to blend the conventions of the comic strip and those of the gag cartoon. He opened the way for a whole new group of cartoonists, including Mick, Roz, and me.

Since 1997, I've been working with Jack as his editor. Seeing the whole range of his work—unpublished as well as published—has only increased my admiration for his art. No matter how often Jack revisits a situation—two guys in a bar, say—his approach is always fresh. He never takes an old drawing and sticks a new caption on it. For him, it's not just "two guys," it's these *particular* two guys. His characters are never approximate—they're always absolutely right.

Jack is one of a kind. He's transformed the whole nature of gag cartooning from the inside. You could analyze how he's done it, but the important thing is that when you're done you look at his drawings and say, "Hey! This is funny!"

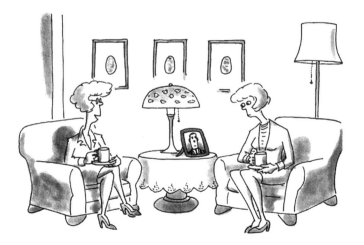

"He would have disappeared long ago had I not had the foresight when we first married to have a tracking device implanted in his left buttock."

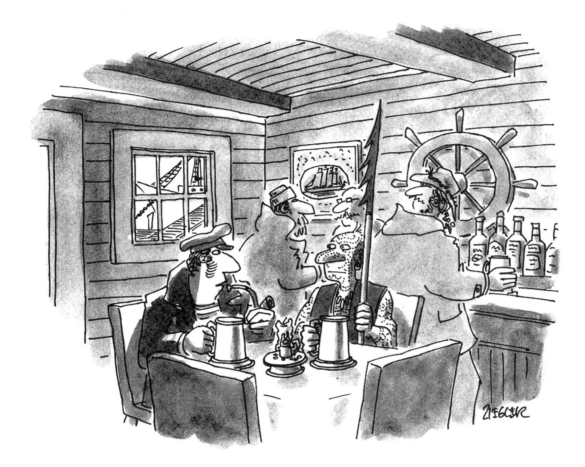

"No health or dental, no stock options, and no severance package. We do, however, provide free burial at sea."

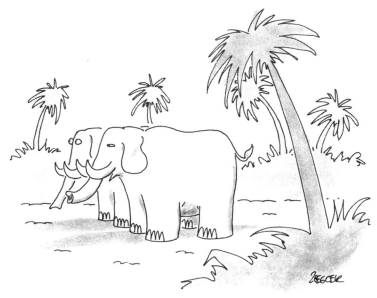

"Wow! Dig the umbrella stands on her!"

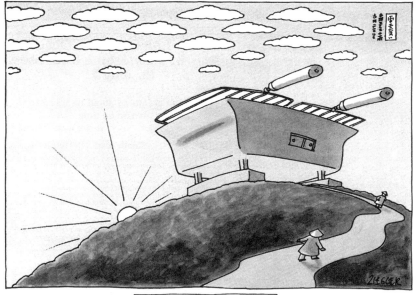

SUNRISE ON MOUNT HIBACHI

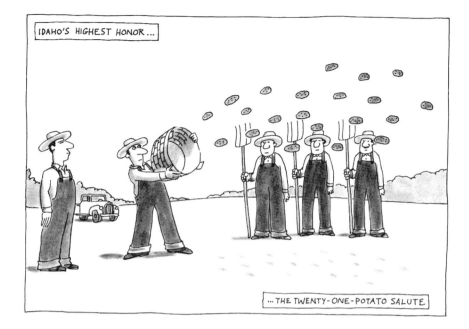

IDAHO'S HIGHEST HONOR...

...THE TWENTY-ONE-POTATO SALUTE

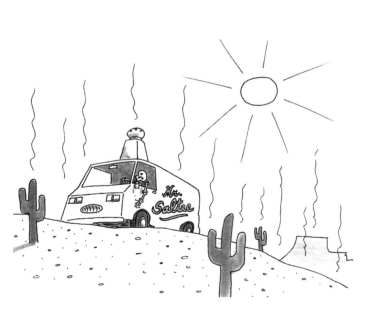

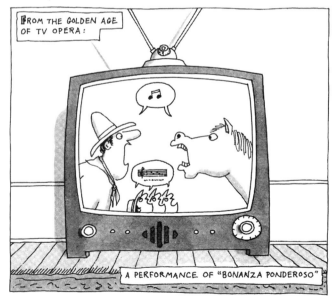

FROM THE GOLDEN AGE OF TV OPERA:

A PERFORMANCE OF "BONANZA PONDEROSO"

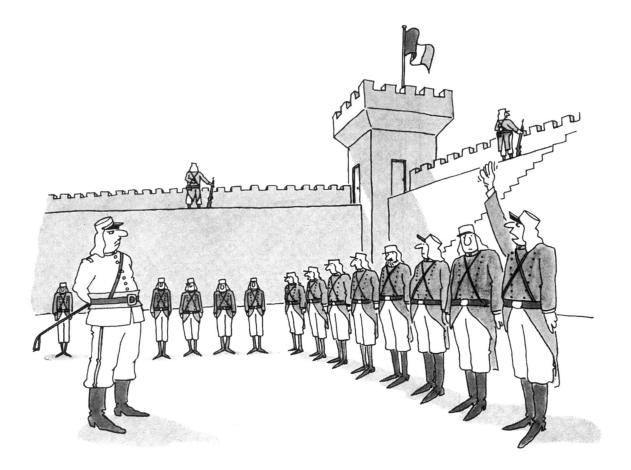

"*Might I point out, Sergeant Drago, that we had a Hawaiian Luau just last year, whereas it's been three years since we've had a Las Vegas Nite?*"

WHAT'S FUNNY ABOUT THAT?

Jack traces his early inspiration to the lurid comic books marketed by EC and the off-the-wall buffoonery of Harvey Kurtzman's *MAD* comics. And yet, aside from his mastery of perspective, there is nothing in his work to evoke *Tales of the Crypt* or *Weird Science*. And the only echo of the slapstick world of Alfred E. Neuman is Jack's persistent weakness for puns. Is Jack kidding us? Or deluding himself? Or is there some connection here not apparent to the naked eye?

I believe there *is* such a connection. The key to Jack's comic genius is his ability to domesticate our most disturbing anxieties by draping them in the reassuring trappings of everyday life. As Exhibit A, I offer the drawing on the next page. A funeral service is being held on a downtown street corner. As the last rites are read, the departed's remains are lowered through the sidewalk on a street elevator. The disparity between the gravity of the occasion and the offhand disposal of the deceased is grotesque, and an artist for *MAD* comics would have made the most of it. A more sumptuous service, choirboys, a hysterical widow, a crowd of onlookers laced with paparazzi. More wattage, but less wit. Jack's secret ingredient is a layer of postmodernist cool. A passing business type glances at the proceedings, but never breaks stride. "Hmmm," he thinks. "A street burial. I think I've read about those—or maybe I haven't. Weird. But then life *is* weird, n'est-ce pas?"

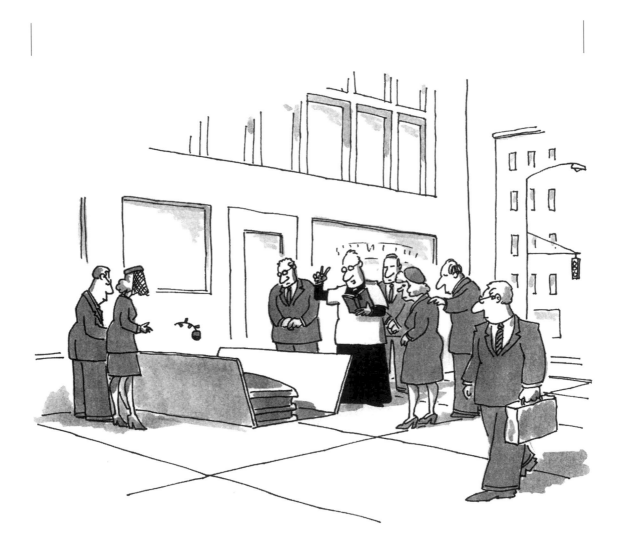

ZIEGLER'S WORLD

Although he steadfastly refuses to view his drawings as anything more than attempts to entertain, there exists a small but equally determined group of admirers who believe Jack Ziegler is one of the sharpest social satirists of our time. I am among them.

Unlike most comic artists, Jack seldom plays off the headlines. (Is there one other major cartoonist who didn't do a single Monica Lewinsky gag?) Yet his work, taken as a whole, constitutes a dead-on, if bemused, portrait of Middle America.

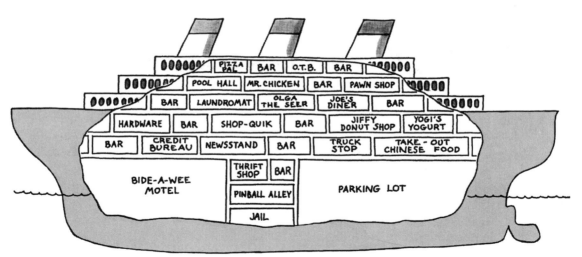

SEMI-LUXURY LINER

Ziegler's people lack the trophy wives and Wall Street expertise of William Hamilton's, and the literary allusions of Ed Koren's West Siders are over their heads. Jack does not share George Booth's interest in the socially marginal, or Gahan Wilson's taste for the bizarre. The parameters of his world are neatly delineated in his drawing titled "Semi-Luxury Liner": OTB on top, Jail on the bottom, and seventeen bars and fast-food joints in between.

Jack's take on late-twentieth-century America is often merely inspired reportage—the class photo of Mrs. Wanda Projhieki and the children of the

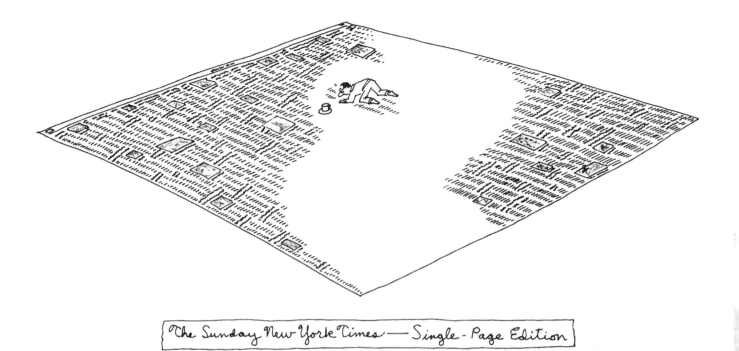

The Sunday New York Times — Single-Page Edition

Peter Rabbit Nursery School, for example. But his special talent is for discovering the surreal in the ordinary, c.f., barber's hair applier and "The Sunday New York Times—Single-Page Edition."

A stroll around Jack's neighborhood takes us past neatly maintained tract houses—kids on bikes, wives hauling in the groceries, and, inevitably, husbands lovingly tending their barbecues. Normalville, U.S.A., and yet things are not quite what they seem. As we turn a corner, we encounter the lawn man delivering leaves. A glance at the street sign tells us that we're standing at the intersection of *Laverne & Shirley*. Snaking through the next block is something that looks like the Alaska pipeline, which the artist identifies as

Pipeline TV. And in place of the tra-
ditional lemonade stand we encounter
a surly youngster with a hammer,
offering his services behind a counter
labeled "stuff broken."

Welcome to the world according
to Ziegler, where the deepest fear is
encountering grown-ups and the most
fervent prayer is to be left alone.

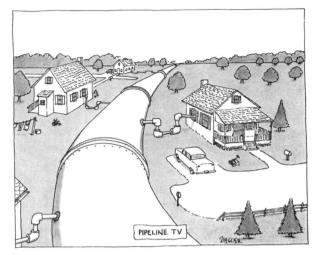

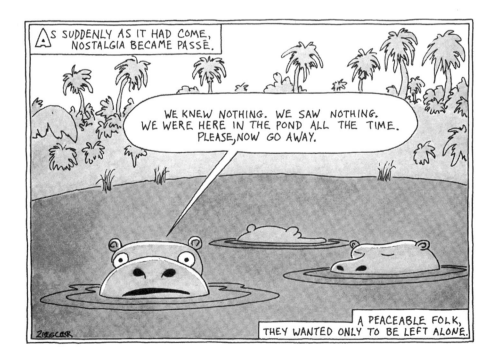

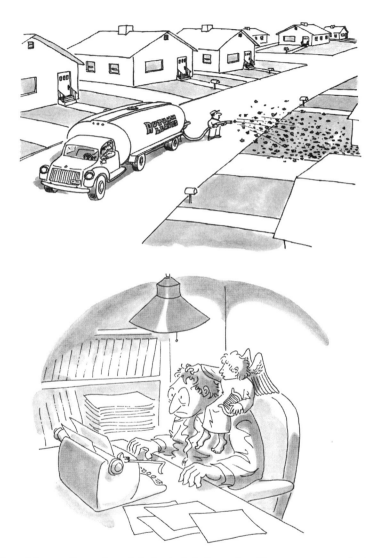

"Hey, I'm thirsty, I need a drink. A drink and a liverwurst sandwich.
Hey, how about a sandwich and a beer down at Gallagher's,
and then we can go shoot some pool? Or maybe take in a movie.
Hey, I'm talking to you."

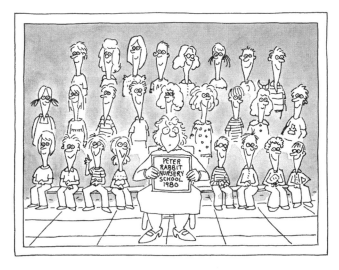

Last Row: Scott, Jennifer, Jennifer, Scott, Jennifer, Jennifor, Scott, Scott
Middle Row: Jennifer, Jennifer, Scott, Scott, Jennifer, Jennifer, Scott Jennifer, Scott
Front Row: Jennifer, Scott, Scott, Jennifer, Mrs. Wanda Projhieki, Scott, Scott, Scott, Scott

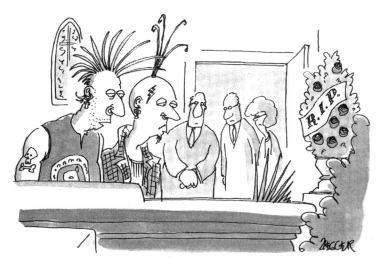

"You've got to admit—he looks good."

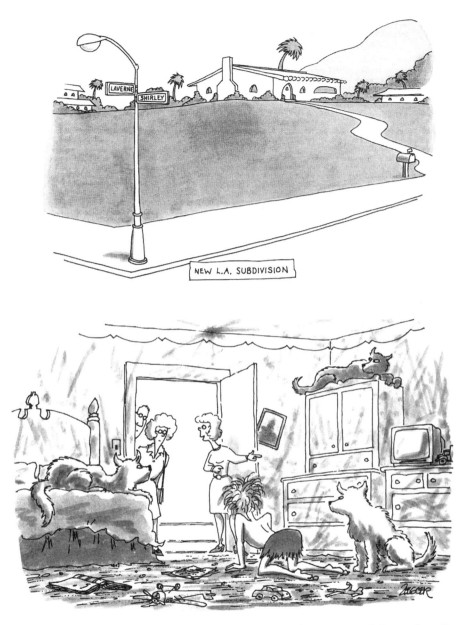

"And this is our son Danny's room. Danny is being raised by wolves."

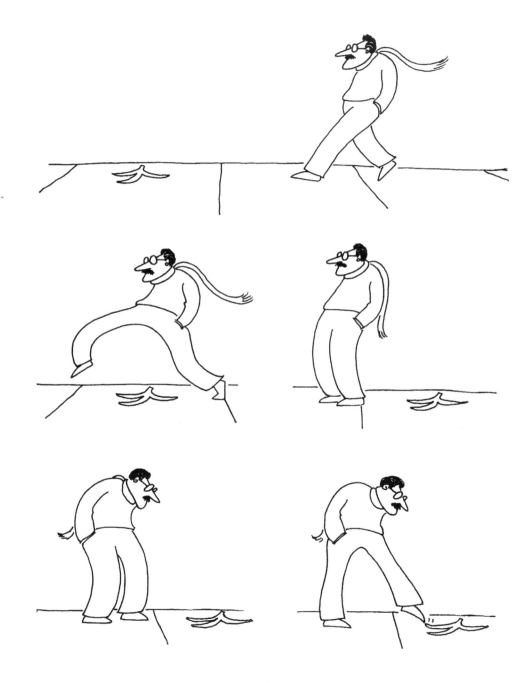

MALE/FEMALE

Sex, or more accurately, the struggle between the sexes, is one of the staples in every cartoonist's cupboard. Jack is no exception. Jack and Jean Ann divorced in 1994. In 1996, Jack married Kelli Gunter. And given that his stats—two wives, three kids—parallel the national average, his rather mild take on the gender wars is not surprising. In Jack's world, Scarsdale wins out over Sodom and Gomorrah. There are no orgies, no wife swapping, and no silicone-enhanced gold diggers. The battle lines are established at the altar, and the opposing forces map their strategies from their respective power

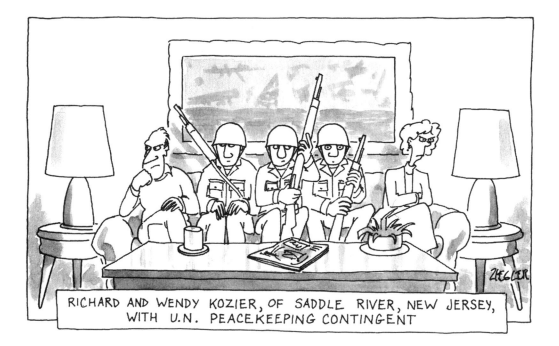

RICHARD AND WENDY KOZIER, OF SADDLE RIVER, NEW JERSEY, WITH U.N. PEACEKEEPING CONTINGENT

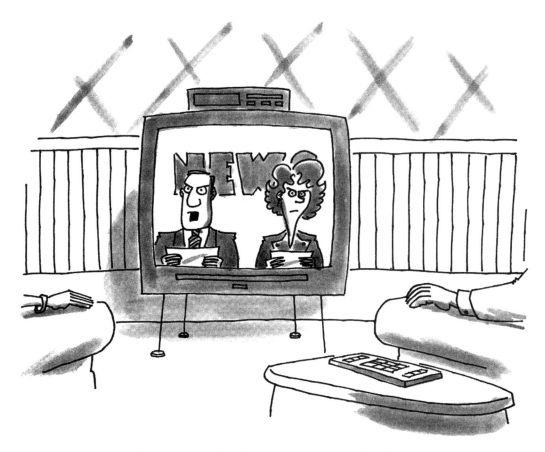

"Now here's my co-anchor, Nancy, with a conflicting account of that very same story."

bases—the bedroom and the barroom. Although threats and counterthreats may peel the wallpaper, the choppy waters of matrimony seem preferable to the Sargasso Sea of the single scene. There are no swingers in Jack's world, just lonely souls microwaving dinner as a bitter tear rolls down the cheek.

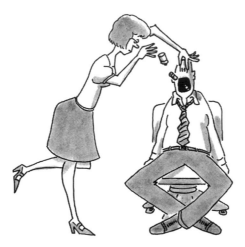

One C battery, two double A's

"Honey, I'm home."

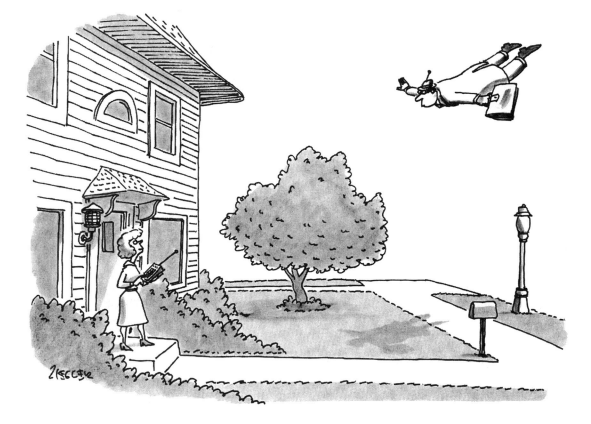

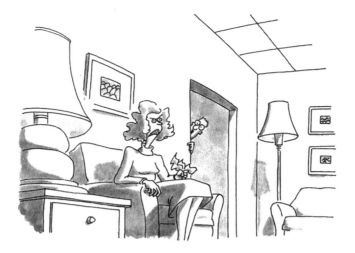

"I forgot our anniversary and you don't feel good about it, and, hey, that's O.K."

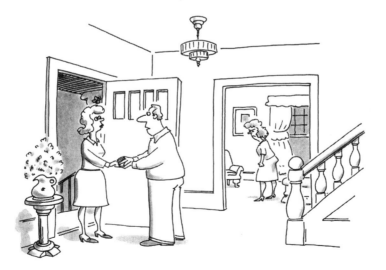

"Janet, we have to stop meeting like this. It has become a source of increasing friction in my marriage to Elizabeth."

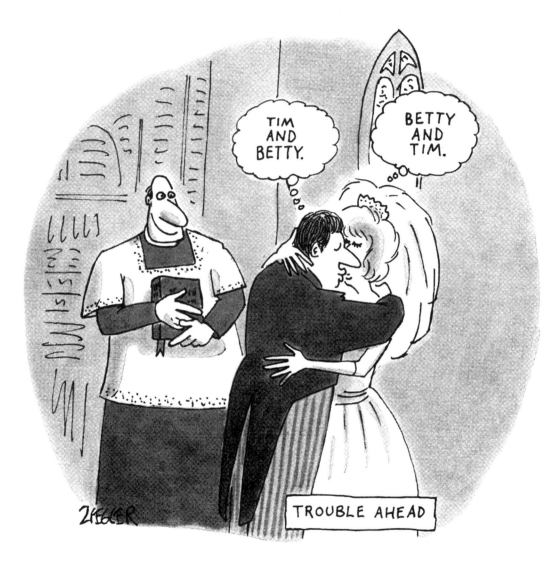

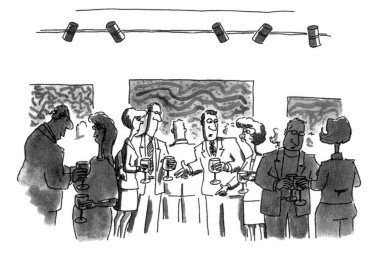

"And this is Helen, my wife by a previous marriage."

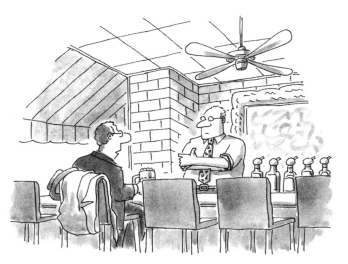

*"Right now we're at a budget impasse. I maintain that you provide
an essential service, and my wife feels that you do not."*

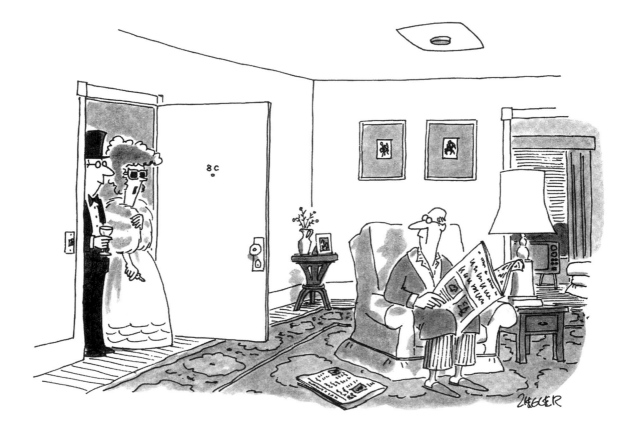

"The truth hurts, Leo, and this is going to hurt a lot."

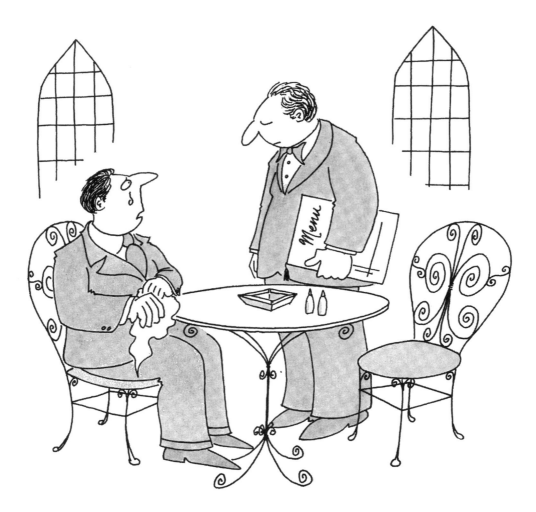

"Would you please have the orchestra play 'Tea for Two,' and I'll just have tea for one, thank you."

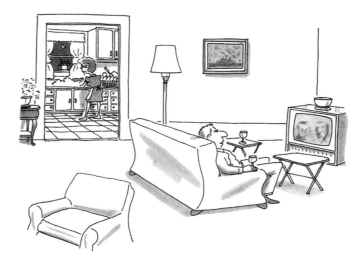

"By the way, hon, great food, great wine, great you."

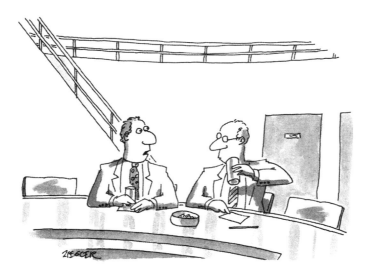

"Cassandra and I are splitting up, Ted, and we'd
like you and Amy to have the kids."

ALL YOU CAN EAT

Flipping through a collection of Ziegler's cartoons, a sensitive person might conclude that Jack grew up on an empty stomach. Eating and drinking, food, and references to food abound in his work. (To illustrate an article about his career, Jack once drew himself as a severed head—suitably garnished—served on a McDonald's tray. The title: "Self-Portrait with a Side of Fries.")

Inscrutable drawings like "Applesauce, Pea Soup, Candied Yams" suggest that his preoccupation with toast and burgers carries some deeper, hidden meaning. Any temptation to read these sketches as metaphors for, say, the insatiable appetites of our consumer society is, however, firmly discouraged by the artist. "Let's face it," he says. "Food is funny."

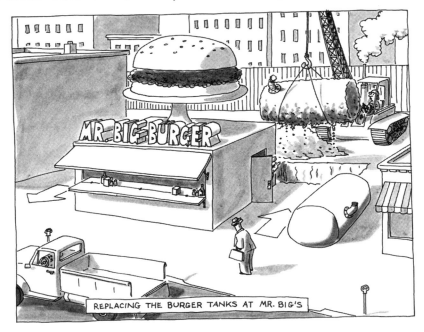

REPLACING THE BURGER TANKS AT MR. BIG'S

BUDGET MUNCHIES

Swedish Furballs

Devilled Ice Cream Cones

Carved Logs of Jerky de Bœuf

Fish Quickies

Peanut Butter and Jelly Sandwich Quiche

Ravioli Puff Fondue

Diet Nibbles

Assorted Snacks

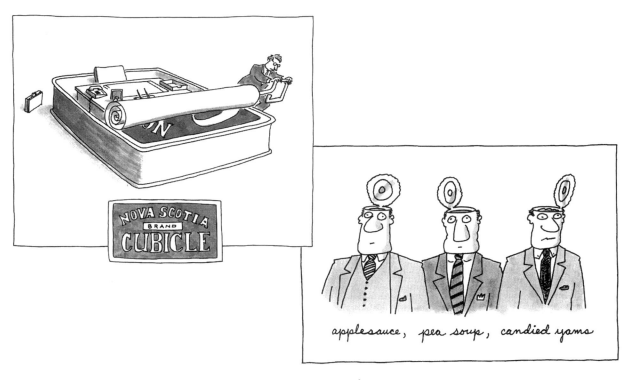

NOVA SCOTIA BRAND CUBICLE

applesauce, pea soup, candied yams

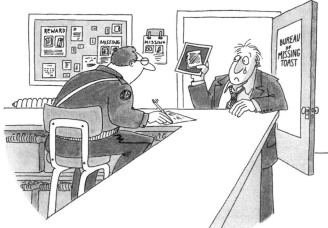

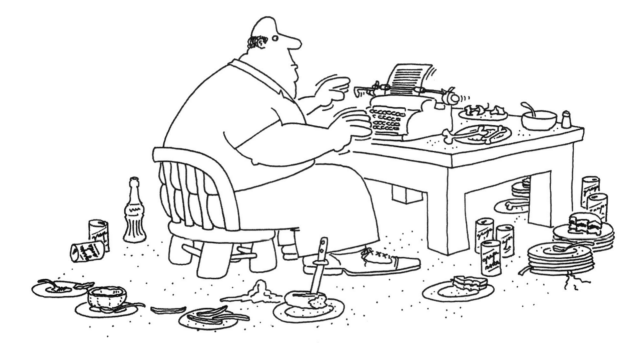

"*The face of the pear-shaped man reminded me of the mashed turnips that Aunt Mildred used to serve alongside the Thanksgiving turkey. As he got out of the strawberry-hued car, his immense fists looked like two slabs of slightly gnawed ham. He waddled over to the counter and snarled at me under his lasagna-laden breath, 'Something, my little bonbon, is fishy in Denmark.' Slowly, I lowered my grilled cheese sandwich . . .*"

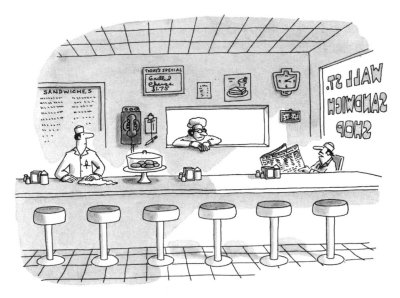

"Liverwurst is down an eighth, egg-salad is up two and a half, and peanut-butter-and-jelly remains unchanged."

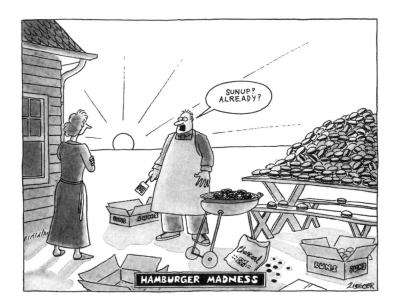

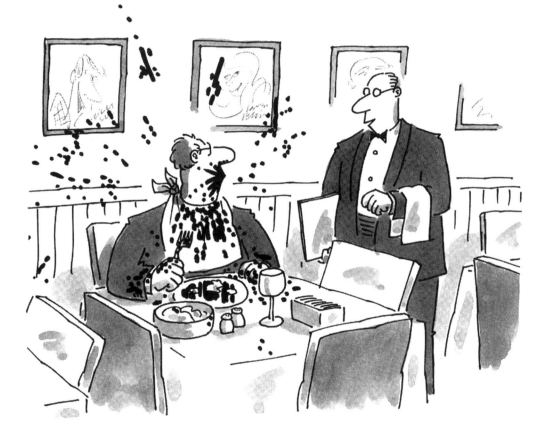

"How's the squid?"

ORPHANS OF THE INKWELL

All artists want to bury the sins of their past. The missteps of apprenticeship can be omitted from personal anthologies, but there is no way to prevent them from surfacing in more general collections. Encountering one of these disowned children can be a humbling experience for even the most accomplished artist. (William Steig took the extraordinary precaution of burning the accumulated drawings of his first ten years.) Ziegler is no exception to this rule, but there is a discernible note of pride in his account of early transgressions.

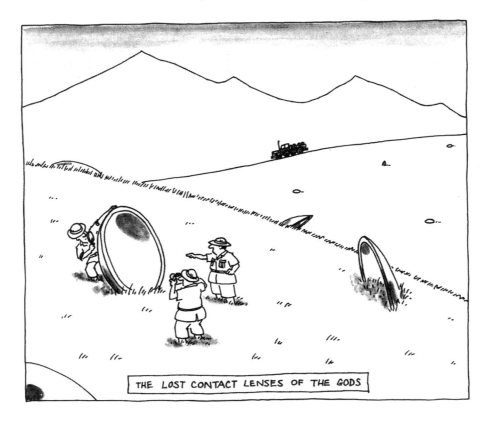

THE LOST CONTACT LENSES OF THE GODS

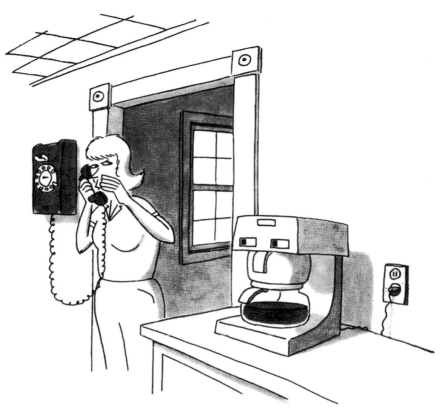

"I can't alk-tay ow-nay."

"Most of my early cartoons were puns—really awful puns," he says. "I think one of my first sales was a drawing of an old carpenter in a medieval work-room talking to his son. The caption was 'Someday, my son, this will awl be yours.' Shameful."

Over the years, Jack hasn't so much abandoned the pun as transformed it. Often the pun is visual: Charles and his Radio, for example, or the hilariously sinister Mr. Coffee. The best of these constitute an as-yet-unnamed extension

of the genre that combines punning, free association, and a sort of shaggy-dog punch line. Only Charles Barsotti at his wackiest could rival "Metro-Goldwyn-Macaroni" or "Thirty Sumos over Tokyo."

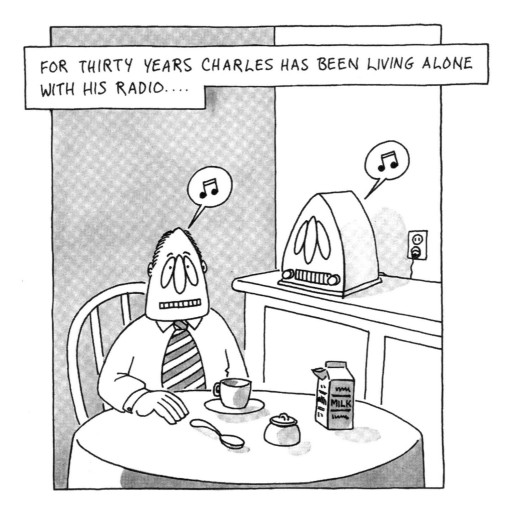

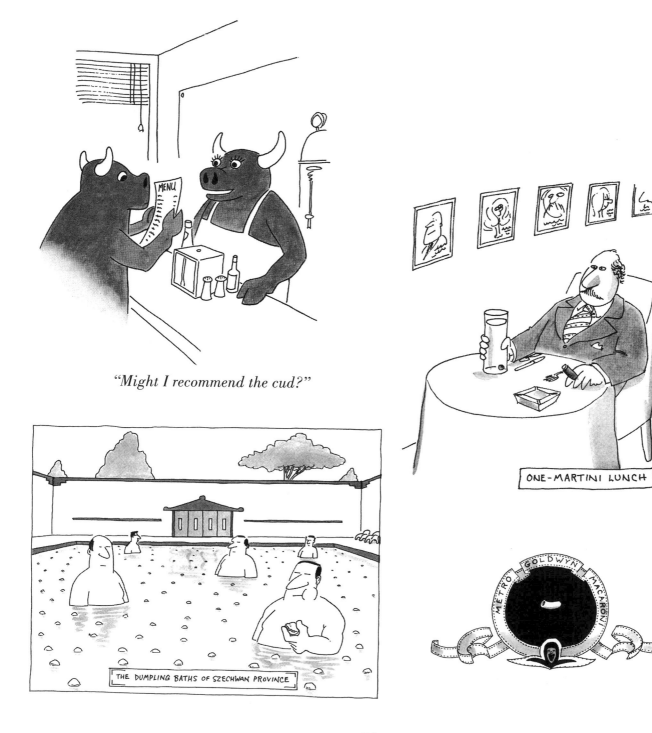

"Might I recommend the cud?"

THE DUMPLING BATHS OF SZECHWAN PROVINCE

ONE-MARTINI LUNCH

METRO GOLDWYN MACARONI

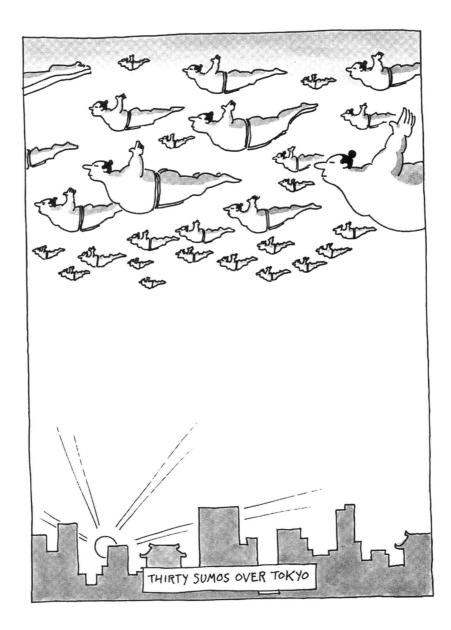

THIRTY SUMOS OVER TOKYO

100

TALES FROM THE CRYPT

For every cartoon drawing published in *The New Yorker,* fifty are rejected. Having worked on both sides of the editorial desk, I view this painful statistic more charitably than do most contributors. There is only so much space available in the magazine, and the editor's job is to see that everyone gets a fair shot. Sadly, I must confess that few cartoonists share this view. To the bulk of them, the editor is not a kindly disposed collaborator, but rather an unsympathetic and dim-witted adversary, blind to what is most original in each artist's work. One regular *New Yorker* contributor would end our weekly meetings by solemnly inspecting the rejected roughs while making loud noises of astonishment and contempt. Once again his favorites were being passed over. Another artist regularly suggested that only the cartoonists themselves were competent to edit their work. As an artist myself I had to admit that this idea had merit, but as an editor I felt required to point out that it would mean publishing on the order of six hundred drawings in each issue.

THE SILICON BRAIN IMPLANT

Of course, even these diehards will concede that occasionally, through inadvertence or sheer blind luck, a favored drawing actually does get purchased.

"Uh oh, chariots-of-the-gods-time again."

But there is another fate more painful than rejection—oblivion. Occasionally, for reasons of editorial conflict or lack of space, one of these favored children fails to make it into print. With the passage of time, even the best ideas grow stale. At the end of each year, these unbloomed flowers are weeded from our banks by the accounting department and returned to the artists. For a cartoonist there is no sadder sight than these stillborns being shipped home in their craft paper shrouds labeled simply "Killed."

Although the artists have been paid for these drawings and they are now free to sell them elsewhere, few do. Why put your favorite children in harm's way twice?

The following pages offer Jack's own selection of favorite editorial road kills. Having originally OK'd many of them myself, I gratefully second his decision to offer them once more to the public.

"Well, that's enough of this. Let's go home and see what's for dinner."

"White man heap big pain in the ass!"

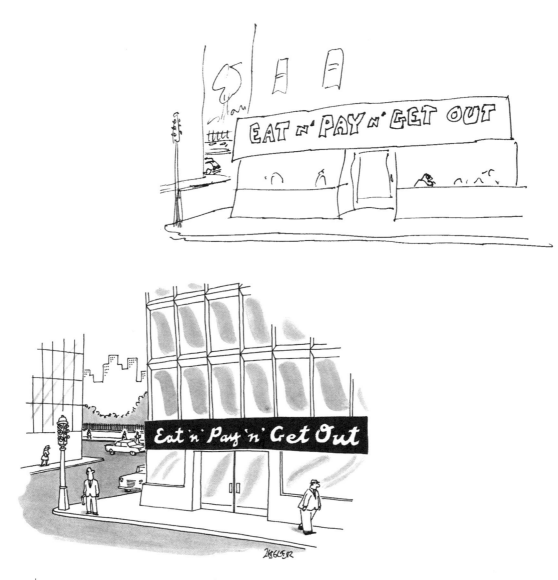

From sketchbook (top) to printed page—
The New Yorker, August 9, 1982.

PORTRAIT OF THE ARTIST AS A WORKING STIFF

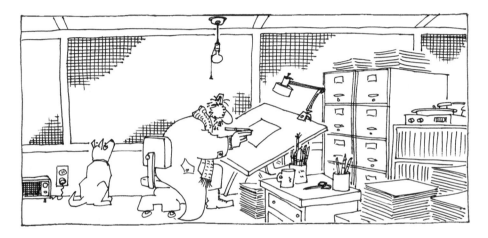

Since 1973, Jack's work space has evolved from the cramped corner of a tiny apartment to a comfortable but hardly luxurious studio in his recently purchased home in Las Vegas. "My wife, Kelli, is a singer, and we moved out here because there's so much work in the area. I know it surprises my friends, but I actually like it here. Most Easterners, who've never been to Vegas, have a very negative view of this place that probably has something to do with Siegfried & Roy, Liberace's wardrobe, and the fat version of Elvis Presley, but it's an incredible place to live."

Jack's schedule, like his tool kit, is designed to maximize production and minimize fuss: "I work five days a week. I used to keep the weekends free

for my kids, but they're all grown now. My workweek really ends on Monday, when I fax stuff off to *The New Yorker*. And then the next week starts up again on Tuesday. Weekends are floaters now, depending upon my wife's days off.

When I'm working, I start about eight-thirty in the morning. I have coffee and I read *The New York Times*. I also read a bit of whatever book I'm into at the moment. I spend the mornings working on ideas. I free-associate. Sometimes it flows, as if my hand had a mind of its own, and sometimes nothing happens at all. Either way, I don't eat anything till lunchtime. For some reason, I feel more creative on an empty stomach. After lunch I turn on the stereo and work on drawings. I always have music going while I draw, but not when I'm doing ideas. Before we moved out here I traded in all my vinyl, and now everything is on CDs. I like classical, jazz, some pop, but mostly rock and roll, from the fifties through the millennium. I usually knock off around six.

"On a good day, I come up with two or three ideas. I rough them up in pretty finished form, so if I get an OK I can just trace the drawing over. These days I draw with a waterproof Uni-Ball Vision pen. I do my roughs on 20-lb. typing paper and my finishes on a flexible bristol board with a vellum finish. I usually add a little halftone wash to my finishes. I work on a

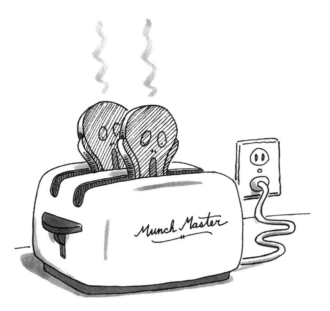

huge old drawing board—I guess you'd really call it a drafting table—that I bought from the widow of an old Disney animator."

Jack's work space is uncluttered and very well organized. His published and unpublished drawings are filed in an old treasure from an antique auction —a thirty-drawer oak file cabinet, circa 1890. His file headings include the predictable work, such as Travel, TV, Sports, Men & Women, along with some surprises: Foolish Behavior, Egotism, Men in Trouble, Philosophy and the Meaning of Life, Insularity and the Mind. "I am interested," he explains, "in what people do when they are alone." Strangely missing are two of Jack's signature subjects—hamburgers and toast. Of hamburgers he will only say, "The whole barbecue thing is weird." About toast, he is only marginally more forthcoming: "Well, I do love old toasters, those super-chrome jobs. I once

found a great one at a flea market, and I've always regretted that I didn't buy it. I'd have it right up there next to my books."

Lacking a toaster, the shelves in Jack's studio hold no surprises. Books, CDs, magazines, carefully marked tearsheets, and spare art supplies. The one decorative note is supplied by Jack's collection of cartoons. Drawings by Mankoff, Stevens, Woodman, Chast, Gross—each neatly matted and framed. "I began swapping drawings with friends a few years ago," he says, "but I had to stop when I ran out of wall space." The windows frame a spectacular view of Lone Mountain (elevation: 3,300 feet), and in the middle distance is a low, crenellated structure that Jack identifies as a water-detention basin. "It's really just a hole in the ground. The idea is, if there's some kind of terrific runoff from the mountains, the basin will divert the water before we're all washed away. Nobody knows if it will really work." Jack pauses reflectively. "I suppose one day we'll find out."

Color sequence from *The New Yorker.*

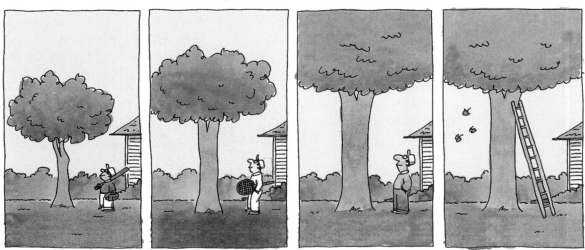

SHOPTALK

For the professional cartoonist, drawing is drawing for reproduction. This simply means learning how to anticipate the manner in which the photo-mechanical (or today, digital) preparation of your material for the press will affect its appearance on the printed page. A reliable rule of thumb is "the simpler, the better." The firm, even pen line of Charles Barsotti can be—and has been —successfully reproduced on postage stamps. At the other end of the scale, Charles Addams' elegantly complicated wash drawings have never looked so good elsewhere as they have on the pages of *The New Yorker*. In fact, *The New Yorker*'s commitment to quality reproduction often put the makeup department at odds with one of the magazine's most distinguished contributors, Saul Steinberg. Steinberg felt that drawings done for reproduction, as opposed to drawings created to hang on a wall, should proudly carry any remaining evidence of the creative process. Random ink spots, incomplete erasures,

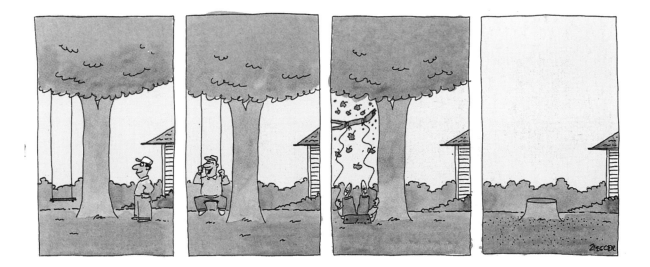

even fingerprints. Other artists were more than happy to have their work tidied up for publication. For George Booth, the shadows cast by innumerable paste-ups were routed out. For Frank Modell, the sharp edges created by correction fluid laid down over halftones were softened. And for the artists too distracted to sign their own work, signature transplants were miraculously accomplished from previously published drawings.

By the time Jack Ziegler came to *The New Yorker*, he had already encountered, and solved, the routine problems of magazine reproduction. On-the-job training at *National Lampoon* and *Esquire*, along with some astute editorial suggestions, had led him to a style well suited to even the poorly printed pulp magazines: an uninflected pen line occasionally augmented by a flat, transparent wash. Having forged his style during apprenticeship, Jack was now free to concentrate on ideas.

LEE: Have you reflected on your drawings over the years? Are you a critic of your own work?

JACK: I hate my old drawings, the ones I did for about the first five years. I don't like to look at anything from back then. I've destroyed most of them. But there's a certain point where I'm comfortable with what I see. I'm still fairly happy with what the drawings look like, although when my first book came out, people complained that the drawings were so bad.

LEE: What struck me from the beginning was that when you had to compose a drawing, you composed very well.

JACK: I'm not aware of any actual thinking process when I'm laying something out. I'm just basically drawing what looks right. If I had ever gone to art

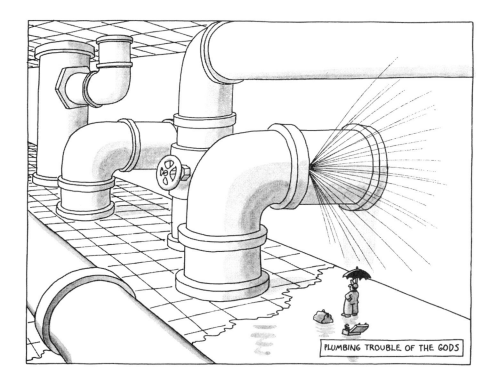

PLUMBING TROUBLE OF THE GODS

school, I probably wouldn't be able to do it as easily as I do. But I find that just putting everything where it belongs is one of the easiest things about it.

LEE: Is that right? I remember the drawing "Plumbing of the Gods."

JACK: "Plumbing Trouble of the Gods" . . .

LEE: Right. That's a beautiful drawing of a challenging idea, and it's wonderfully composed. There are very few cartoonists who can do that. The perspective is nothing fancy, but it's correct. The scale—the relationship between the plumber and the plumbing—is just right. And the fittings themselves are perfect. Not too complicated (imagine how George Price would have drawn it),

but sufficiently complicated to be plausible. And finally, the plumber himself: a signature Ziegler gent—nonplussed but not defeated.

JACK: And that's a mystery to me. I don't know where that comes from, but I do know I was having a lot of plumbing trouble at the time.

LEE: You keep a pretty basic tool kit. What do you draw your finishes with?

JACK: These days, as I said, I'm drawing with Uni-Ball Vision indelible ball-point pens, which are wonderful. I've been using the fine size. For years I was drawing with a Rapidograph, and I always hated it. It was too slow. It would get clogged. I was always looking for something else, and I could never find anything that I felt comfortable with. Several years ago, someone came out with these Micron Pigma pens and I started using them, but then I didn't like those, either. Then these Uni-Balls came out—they're made by a company called Sanford. They're perfect, and I hope they never stop making them.

LEE: They stop making everything. It's amazing. Do you just use regular watercolor wash?

JACK: I do the drawing first in pencil. Whether it's a rough or a finish, I always do that. Then I just ink it and put a wash on it.

LEE: And when you do color, do you use a different paper?

JACK: I used to use watercolor paper, but I don't like it, so I've been using a bristol board—the stuff I do finishes on. It's pretty light, very flexible. I like the way the watercolor looks on that, as opposed to the way it turns out on watercolor paper, for some reason. I never use dyes.

Jack's color cover for *The New Yorker*.

Two additional color pieces from the Tina Brown period at *The New Yorker*.

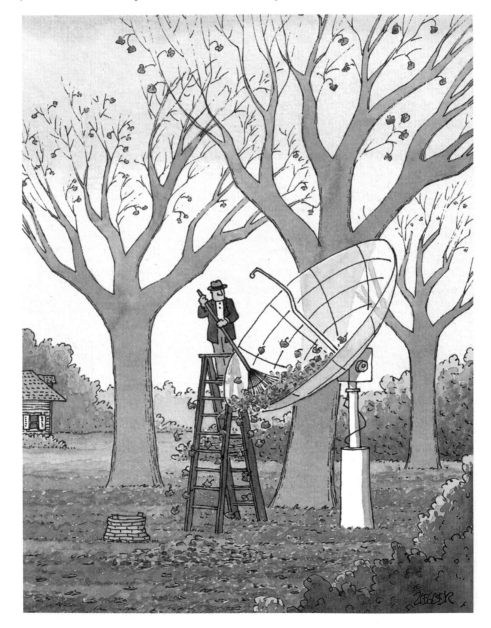

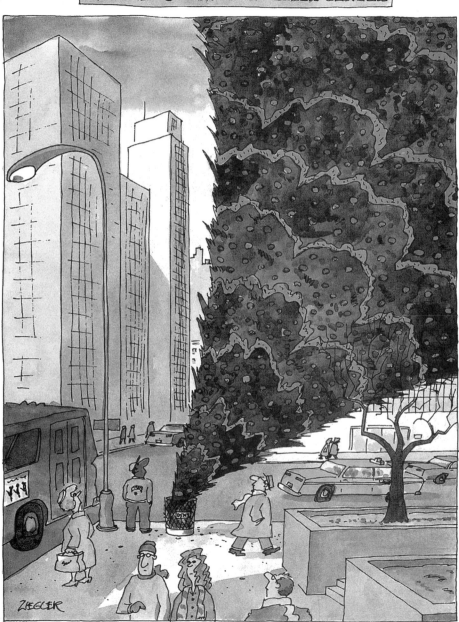

LEE: What do you use for watercolors?

JACK: Just straight watercolors in tubes. And I usually have several of these porcelain Chinese nests and plastic palettes. I just squirt a little paint from the tube onto a plastic palette, let it dry, and work from that over the years.

LEE: Do you like working with color?

JACK: I enjoy it now, but I used to be petrified of color when I first started. As I mentioned earlier, everything I know about color I learned from Harvey Kurtzman when he was buying stuff for *Esquire*.

LEE: What other editors were helpful to you?

JACK: Actually, Michael O'Donoghue at *National Lampoon* was very helpful when I first started. He could really look at my cartoons and tell me exactly what was wrong with them. I was still very much under the influence of adventure comic books. He made me realize that my drawings were too realistic for my ideas. For example, I always drew the jawline running back to the ear. He pointed out that this made my people look like they were wearing masks. He also kept pushing me to take my ideas further—to make them crazier. I think I totally changed my early style after talking with him over a period of time, because he was absolutely right on everything that I was doing wrong.

LEE: Did he have an art background?

JACK: I don't think he did. He was basically a writer, then an editor, and then he went on to invent *Saturday Night Live*. He had a comic strip that ran for a while, *Phoebe Zeitgeist,* but he just wrote it. When he was working at the *Lampoon,* he used to write a lot of comic strips that other people would draw.

THE KING'S PLEASURE

"Kings and Kingdoms" is one of the bulkiest folders in *The New Yorker*'s file of published cartoons. For most comic artists, the king is an irresistible symbol for the vain and powerful. Ziegler, naturally, takes a different tack. His king is a fuddled bozo surrounded by feckless bureaucrats. When the crown of office weighs too heavily on his brow, he merely tosses it on the hat rack and flips on the TV.

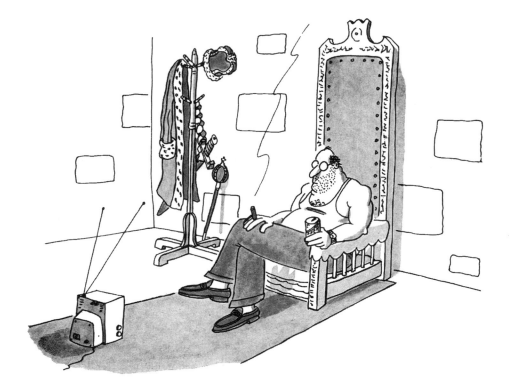

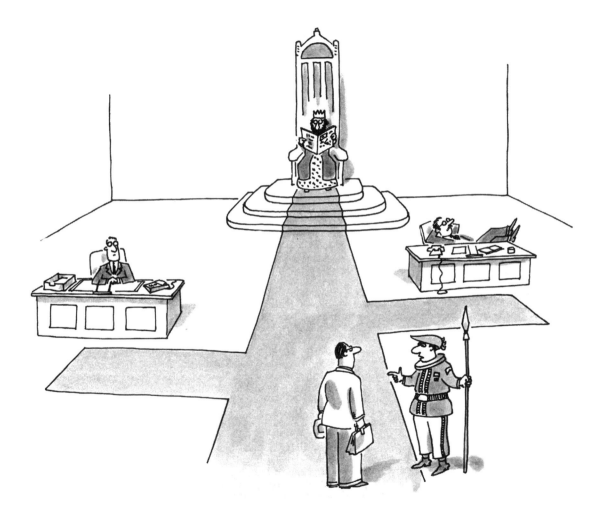

"His Majesty's lawyer will see you now, followed by His Majesty's agent,
after which His Majesty the King will, if all goes well, see you."

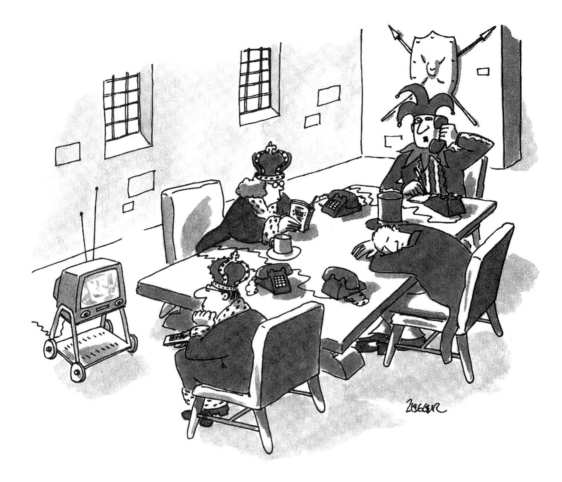

"Hello. You have reached the Palace. If you wish to speak to the King, press '1' now. If you wish to speak to the Queen, press '2' now. If you wish to speak to the Chancellor of the Exchequer, press '3' now. And if you wish to speak to the Minister of Culture—well, hi!"

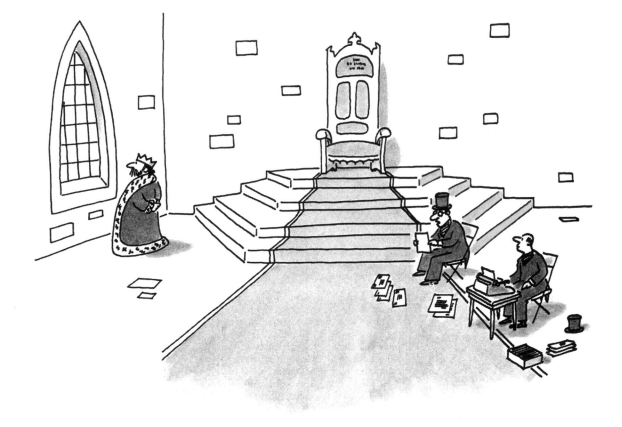

"Here's a letter from a housewife in the southern tier of the kingdom. She writes: 'Sire, would it or would it not be appropriate to use a sand-finish latex paint on a wall on which there remains some painted-over wallpaper? Respectfully, Mrs. R. Jones.'"

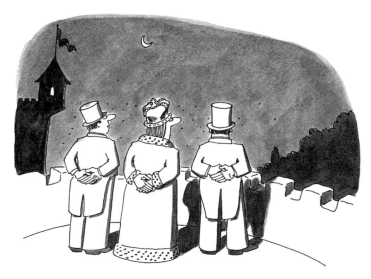

"The tiny winged beings, Sire, are called gnats."

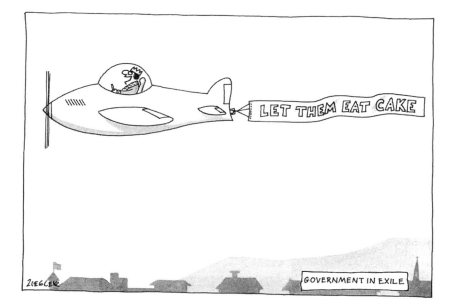

TRICKS OF THE TRADE

LEE: You mentioned that you like to start your workday with a few pages from whatever book you happen to be reading. Do you read a lot?

JACK: Yeah, I've always read a lot. I like to read one fiction book, then a nonfiction.

LEE: What were some of your recent favorites?

JACK: I'm reading a novel right now by Richard Russo called *The Risk Pool*. I discovered Russo through the movie *Nobody's Fool*. The movie was really good, so I read the book. And the book was great, so now I've read everything by him. I like T.C. Boyle. Henry Miller was an early favorite—I read everything by him that I could get my hands on.

LEE: That was in high school?

JACK: No, it was when I was in San Francisco. I sort of discovered him late in life. I liked his whole attitude toward life. Always merry and bright. Do what you want to do—that seemed like a good idea. Paul Bowles, I really like his stuff, especially the novels.

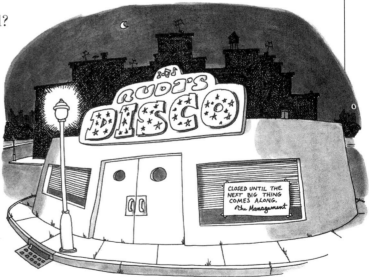

LEE: What about nonfiction?

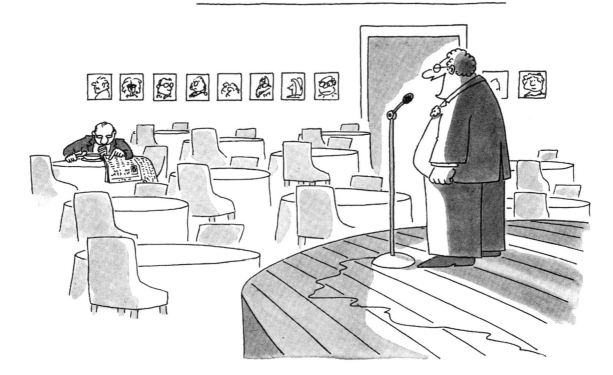

"Hey, hey, O.K.! How many of you have done <u>this</u>? You go to wash your hands and there's this piece of <u>spinach</u> stuck in the soap. Right? Right? And how about <u>this</u>? You fall out of bed in the middle of the night and when you wake up you can't figure out why the ceiling is so far away and the only logical explanation is that you've suddenly become the incredible shrinking man. Right? Recognize <u>that</u> one? Huh? Am I hitting home? Huh? Huh?"

JACK: I try to read as much as I can find about *The New Yorker.* Anything that seems interesting or well written. I'm not looking to read everything about Lincoln, or any particular subject at all. I like good writers. If it's well written, it will be interesting.

LEE: Are there periodicals that you follow to keep up to date?

JACK: I just read the book reviews in the *Times* and see what is published. I used to subscribe to *Rolling Stone,* probably only because I've seen it ever since it first came out, and looked at every issue although there's virtually nothing to read in there anymore. They recently canceled my subscription, because they said I was too old.

LEE: What about films? Do you like to go to the movies?

JACK: I go to the movies all the time. Constantly.

LEE: Who are some of your favorite directors?

JACK: I like directors who have distinctive styles—Scorsese, Kubrick, Truffaut, David Lean, Hal Hartley, Mike Leigh, Jim Jarmusch. I also like the new film-noir type movies like *Clay Pigeons* and *Bound . . .*

LEE: Like *L.A. Confidential*?

JACK: Even that's almost too elaborate. But *Clay Pigeons* and *Bound,* by the Wachowski brothers—I like movies where people are betraying each other. And the Coen brothers' movies I love, just love the way they look. *Raising Arizona* has got to be one of the funniest movies ever made.

LEE: Do you watch television much?

JACK: Not a lot. I used to watch *Seinfield.* The only show I've seen recently that I like is this thing called *Sports Night,* which is sort of a semi-comedy show, like a little David Mamet play every week. But there's nothing I go out of my way to see on television at this point.

LEE: What about live theater or comedy clubs?

JACK: Live legitimate theater in Las Vegas is starting to happen in a big way in the newer hotels. They all have major theater space. There are quite a few comedy clubs, too.

LEE: I always assumed that comedy clubs would be depressing. They're not?

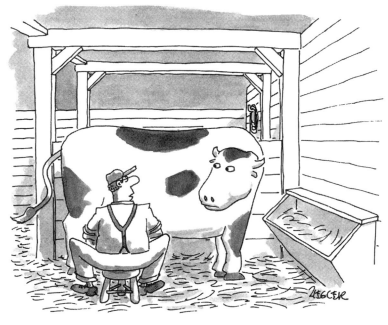

"By the way, dollface, nice hooters."

JACK: Usually not. There must be six hotels out here that have pretty good comedy clubs and fairly good comedians. I used to go to comedy clubs in Connecticut, too. Every once in a while, a club would crop up—in Southbury, for instance—and you'd get really bad people there. But I've seen some good ones in Las Vegas. And then other guys, like Dennis Miller and Dana Carvey, have regular gigs at places like the Desert Inn. Jackie Mason, I like. And Nick Dipaolo.

LEE: I know your wife sings. Does she also do comedy?

JACK: No, although she's quite amusing. She was singing in clubs in Connecticut when we lived there, but she hasn't done that in Las Vegas yet.

LEE: Have you ever tried to write comedy? Any interest?

JACK: No, it's like when I was a kid looking at cartoons in magazines. I figured I'd never be able to do that. Now I see stand-up comedians or sitcoms on TV and figure my humor wouldn't translate.

LEE: Several people from the *Lampoon* moved into television, didn't they?

JACK: Yeah, right. Michael O'Donoghue and Brian McConnachie were involved with *Saturday Night Live*, and Ann Beatts had a sitcom for a while.

LEE: But that's not appealing to you?

JACK: No, I've really enjoyed cartooning. You know, when it's going well.

LEE: Have you ever thought of trying to do a strip?

JACK: I have tried several—not exactly strips, but several daily panel-type things. I thought they were funny. The syndicates didn't agree.

BAD TASTE

In these politically correct times, it has become almost impossible to create a comic drawing that doesn't offend somebody. In response, Ziegler seems to have decided he might as well offend *everybody*. Surely generating outraged letters from animal rights activists, the Noble Order for the Protection of Santa Claus, and the vertically challenged with just one drawing sets an enviable standard.

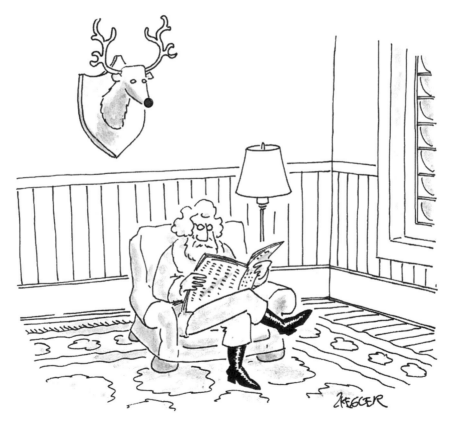

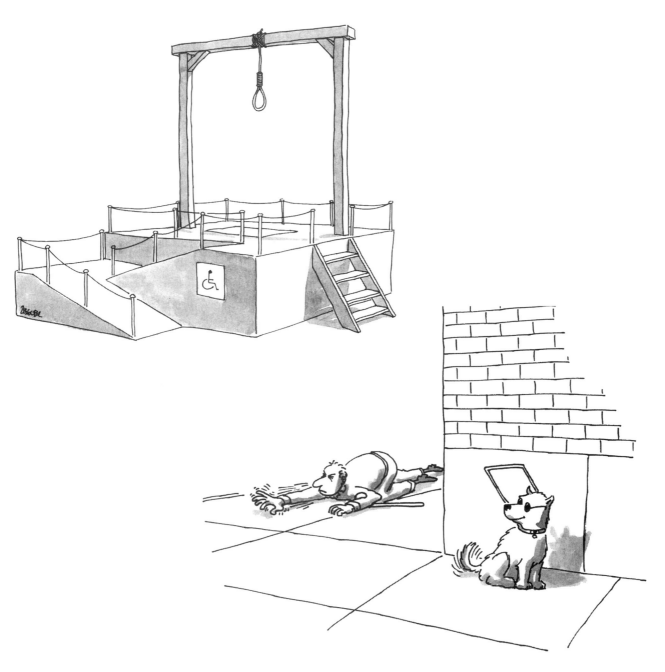

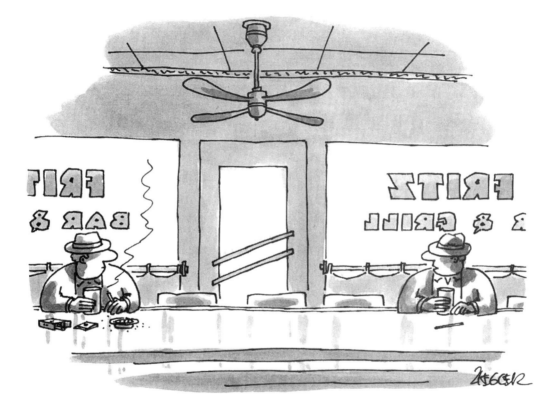

"*I just did a huge one in my diaper.*"

MONEY IN THE BANK

Even *New Yorker* cartoonists as prolific and successful as Jack Ziegler seldom earn more for their efforts than the teller at your friendly neighborhood bank. *The New Yorker* is, however, a powerful showcase, and many contributors generate additional income from advertising, illustrating books, and surprisingly, reprints. Jack has done his share of ancillary work, but a recent boom in the cartoon reprint business has finally made it possible for him to spend more time searching for vintage vinyl on e-bay.

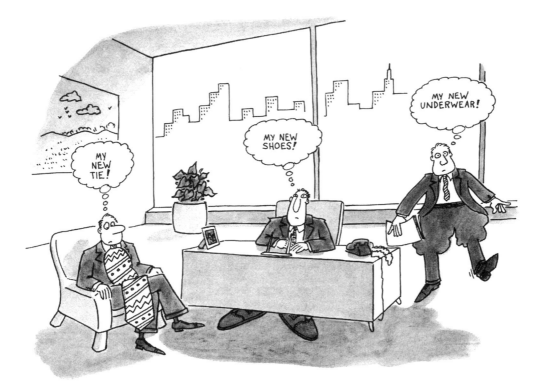

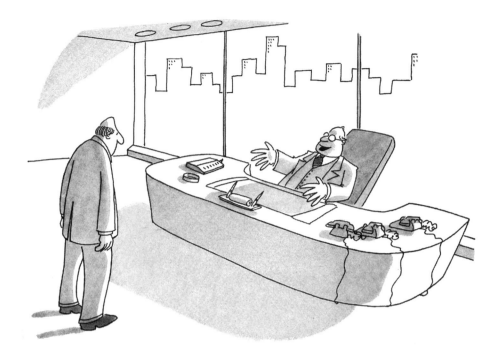

"Bob. Bob, Bob, Bob, Bob, Bob. Bob. Bob, Bob, Bob. Bob, Bob. Bob. Bob, you're fired."

For most of *The New Yorker*'s history, the rights and permissions department, which handled cartoon reprints, was run as a public service. The magazine purchases all reprint rights to the work it publishes. (Original artwork remains the property of the artist and is returned.) Requests for reprint use—in textbooks, for example—have been scrutinized for their impact on the magazine's reputation. Small fees are charged and passed along to the artists. This was considered serendipitous and never exploited as a possible source of revenue. Five years ago Robert Mankoff, one of the magazine's cartoonists, came up with a bright idea that has completely transformed the business of cartoon reprints.

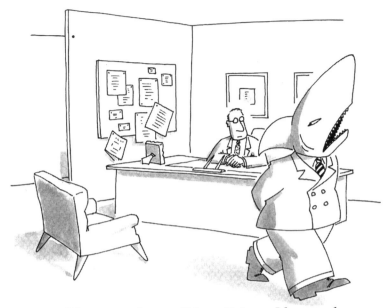

"Please continue talking, Briggs. I have to keep moving lest I suffocate and die."

Like most contributors, Bob produces from fifteen to twenty ideas a week. Selling just one would put him way ahead of his peers, who average between twenty and thirty sales a year. Even at this exalted level, a cartoonist is left with some 950 unsold ideas each year. Mankoff's inspiration was to create an inventory of this unpublished material, solicited from his peers, and aggressively market the rights to it. He called his enterprise The Cartoon Bank.

Digitizing the inventory, some twenty thousand drawings, made it possible for potential customers to select material through the Internet. A promotional campaign designed by Bob's wife and partner, Cory, as well as favorable coverage in the media, quickly put the business in the black. Impressed by Mankoff's success and anxious to reenergize its own reprint operation,

The New Yorker purchased The Cartoon Bank in 1995. Bob, who became *The New Yorker*'s cartoon editor in 1998, remains as president.

In addition to its growing inventory of unpublished cartoons, the Bank now offers *The New Yorker Collection,* or digitized access to the magazine's unsurpassed inventory of published cartoons. At a time when the shrinking marketplace has placed the future of magazine cartooning in doubt, The Cartoon Bank is providing, if not salvation, at least temporary relief.

The Bank offers work by more than fifty artists, but none is as well represented, or as widely reproduced, as Jack Ziegler. "We have about 2,500 drawings by Jack in the Bank," says Mankoff. "And, of course, we offer all of his *New Yorker* stuff through *The New Yorker Collection.* The work is all cross-referenced, so it's a cinch to find appropriate material."

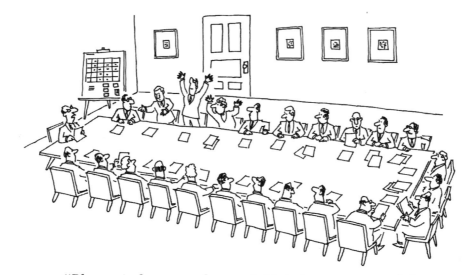

"Please sit down, gentlemen. I think that once around the table with the wave will be quite enough, thank you."

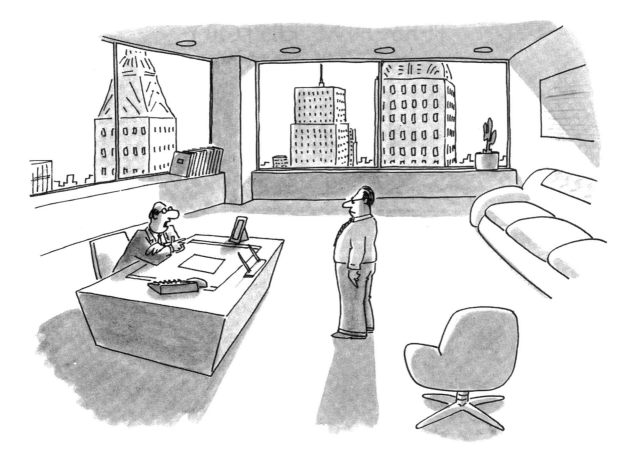

"*Bramwell, did you know that you can earn as much as two hundred dollars extra each month in your spare time by selling shoes in your own home? That's right—as much as two hundred dollars extra in your spare time!*"

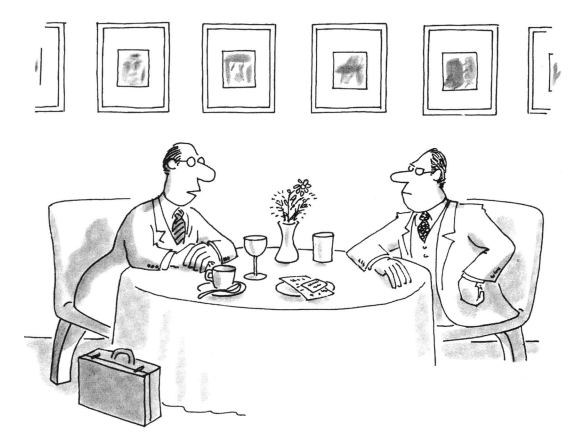

"Bob, as a token of my appreciation for this wonderful lunch I would like to disclose to you my income-tax returns for the past four years."

The success of The Cartoon Bank has made Ziegler's work familiar to an audience much wider than that of *The New Yorker*. Not surprisingly, this success has done little to change Jack's view of himself or enlarge his ambitions.

LEE: Since you've established yourself as a cartoonist, you've done other things, including writing or illustrating children's books. Tell me about them.

JACK: Well, the first one I did was supposed to be called *Babe in the Woods*, but they wound up calling it *Lily of the Forest*. It couldn't be a worse title. Brian McConnachie wrote it, and I did the illustrations. Then we did a second one called *Flying Boy*, which was a really good book, nicely done, with a good story. After that, I did *Annie's Pet*, by Barbara Brenner, for the Bank Street Ready-to-Read series.

LEE: Were you using an agent for any of this, by the way?

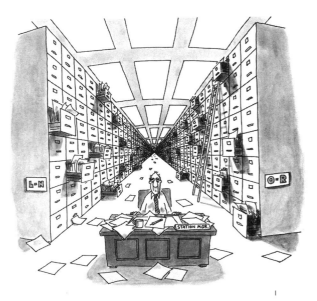

"I came. I saw. I had the Absolut on the rocks."

ABSOLUT ZIEGLER.

The sketch on this page was drawn by Jack as part of a portfolio of *New Yorker* cartoonists celebrating Absolut. Opposite: An ad for a local record shop bartered by Jack for some vintage vinyl and one of a series of promotional drawings Jack did for BMI (this time he took the cash).

Billy Hanley

agent. Maybe I should have. Could have saved a lot of heartache, probably.

LEE: What about advertising? You've done some of that.

JACK: I've done some advertising, but I never got a lot of work. Then I did my own children's book, *Mr. Knocky,* and it took me forever to sell that thing. I must have sent it to thirty different publishers before I found one who actually liked it. That was Macmillan. But right before publication, Macmillan's owner, Robert Maxwell, committed suicide by jumping off a boat, or maybe he was pushed. Chaos ensued, and then my editor left and *Mr. Knocky* became one of those lost books. It came out two months before it was supposed to. I wasn't even aware it was out. I never even saw it in a bookstore, although they apparently sold some somewhere. So, a publishing nightmare. Then I've done other illustrations for a variety of humorous books, some funny, some not.

possible narrator

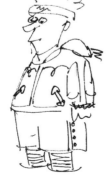

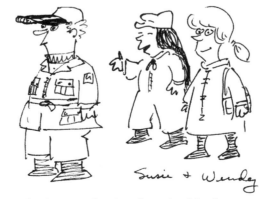
Susie + Wendy

Character development drawings from sketchbook.

LEE: Have you ever tried to do any other writing?

JACK: I was fairly well cured after my novel, although I did a little piece called "Snatchcrackers" for a National Lampoon book called *The Job of Sex*. It was sort of a takeoff on *The Joy of Sex*. Then the editor of *Connecticut Magazine* wanted me to do a piece on my favorite spot in Connecticut. They had asked several different people to do articles on their favorite spots, usually something serene and bucolic. I think that was the last thing I wrote. It was about a saloon.

LEE: Some of those spreads you did for *The New Yorker* had a lot of writing. They were beautifully done. Have you considered doing more?

JACK: I've done some other spreads, but they're sitting it out down at the Stack O'Rejects Café. The only writing I do now is the cartoons. And the occasional e-mail.

MR. KNOCKY

141

CORPORATE-SPONSORED BIOGRAPHIES
OF THE GREAT

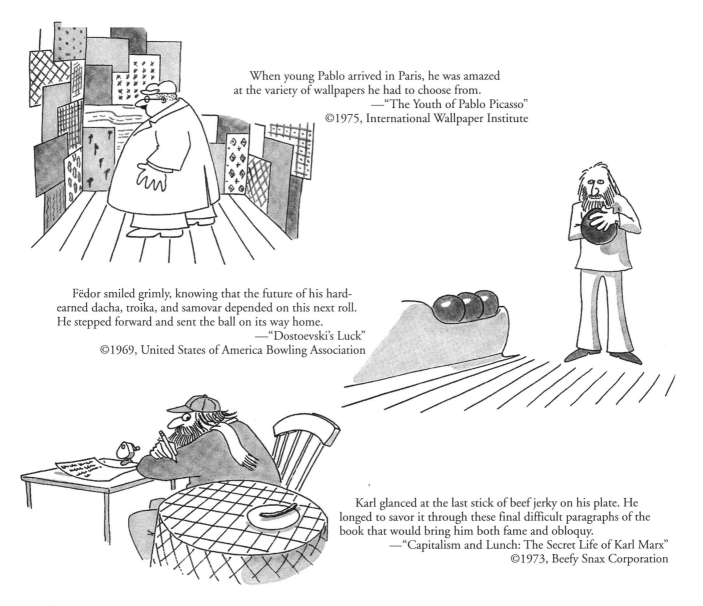

When young Pablo arrived in Paris, he was amazed at the variety of wallpapers he had to choose from.
—"The Youth of Pablo Picasso"
©1975, International Wallpaper Institute

Fëdor smiled grimly, knowing that the future of his hard-earned dacha, troika, and samovar depended on this next roll. He stepped forward and sent the ball on its way home.
—"Dostoevski's Luck"
©1969, United States of America Bowling Association

Karl glanced at the last stick of beef jerky on his plate. He longed to savor it through these final difficult paragraphs of the book that would bring him both fame and obloquy.
—"Capitalism and Lunch: The Secret Life of Karl Marx"
©1973, Beefy Snax Corporation

Freud lay down on the lounge chair. The gentle buzzing of the mosquitoes soon lulled him to sleep, and he dreamed a dream that would change the face of psychology forever.
—"Interpretation of Freud"
©1958, Lawn Chairs Unlimited of Pasadena

Villa readjusted his sunglasses against the blazing Mexican noon and stared out across the vast expanse. "So this is it," he murmured. "The whole enchilada."
—"Pancho Villa: The Action Years"
©1963, Sun-Ban Company

Although Fiorello LaGuardia and Albert Einstein laughed and laughed and laughed at the joke, their socks did not fall down.
—"A Remarkable Friendship"
©1971, He-Man Hose Manufacturing Company

"I found myself in a small room. Soundlessly the doors slid shut after me and a sequential series of numbers on the wall began to light up - one after another. Some sort of countdown, I figured, or perhaps a trick. I became aware of a faint whirring sound and got the weird feeling I was being taken for a ride. Yet I was standing still! A fist tightened inside my stomach and I felt sick. My ears began to pop like cheap gum. Pop! Pop pop pop! This case was beginning to take on bizarre proportions, all right."

THE VIEW FROM VEGAS

LEE: You have a lovely wife, a successful career, a pleasant home, and three grown children, none of whom have served time. Do you have any further ambitions?

JACK: I recently purchased some oils, brushes, and canvases. My wife had been after me to do that for the longest time. My daughter, Jessica, teaches art, so she was on my case, too. The last time she visited, she dragged me out to Red Rock Canyon to do my first painting. The wind was blowing at a steady gale of about forty knots, so a good portion of the canyon wound up stuck to my canvas. I call it *Big Dirty Piece of Crap.* That satisfied my ambitions for the near future.

LEE: How about the far future? Is there anything that particularly inspires you?

JACK: I really don't know. I look at art by Picasso and Steinberg and get really motivated and want to do the kinds of things that they do. But I can't seem to do them. I can't figure out the logistics. So I'll probably start by painting the water-detention basin that's outside our house, and then move on to the mountain that's behind that and then out into the desert. I don't know. I would begin with something that was there and then try to find my way, I guess.

Like all artists, Jack *did* find his way by beginning with what was there. In the forties and fifties, it was World War II, Hitler, and the atom bomb. Then came Joe McCarthy, Alger Hiss, and the Cold War. With Vietnam, the Cold War grew hot. The sixties spawned the Civil Rights Movement, the Counterculture, and, eventually, Watergate.

After a failed attempt to articulate a response to those tumultuous decades in a novel, Jack began to find his own voice—not as a writer but as an artist. Gradually he developed a unique syntax that blended the comic books of his childhood with the black rhythm and blues and doo-wop of his adolescence. As we lurch into the twenty-first century and the world of print recedes behind us, the prospects for Jack's kind of comic art seem increasingly problematical. But whatever value the future puts on Jack's work his position in the history of twentieth-century cartooning is secure.

The brilliant cartoonist Harvey Kurtzman declared that Jack's drawings have "a certain touch of madness."

Jack's current editor, Robert Mankoff, says simply, "He's a genius."

Such hyperbole makes the artist uncomfortable. His own view seems closer to that of his friend and fellow cartoonist, Bill Woodman. "Oh, Jack," he says. "He's just nuts, that's all."

A ZIEGLER BIBLIOGRAPHY

COLLECTIONS OF DRAWINGS

HAMBURGER MADNESS. Harcourt Brace Jovanovich, 1978.

FILTHY LITTLE THINGS. Doubleday, 1981.

MARITAL BLITZ. Warner Books, 1987.

CELEBRITY CARTOONS OF THE RICH AND FAMOUS. Warner Books, 1987.

WORST CASE SCENARIOS. Simon & Schuster, 1990.

CHILDREN'S BOOK (AUTHOR & ILLUSTRATOR)

MR. KNOCKY. Macmillan, 1993.

CHILDREN'S BOOKS (ILLUSTRATOR ONLY)

Brian McConnachie, LILY OF THE FOREST. Crown, 1987.

Brian McConnachie, FLYING BOY. Crown, 1987.

Barbara Brenner, ANNIE'S PET.
Bantam (BankStreet Ready-to-Read), 1989.

Marc Kornblatt, ELI AND THE DIMPLEMEYERS. Macmillan, 1994.

HUMOR BOOKS (ILLUSTRATOR ONLY)

Eleanor Rowe, WAITING GAMES. Facts on File, 1983.

Pamela Pettler, THE JOY OF STRESS. Quill (William Morrow), 1984.

George Thomas, M.D., and Lee Schroiner, M.D., THAT'S INCURABLE!
Penguin, 1984.

Christopher Graybill, MODERN SUPERSTITIONS. Pinnacle, 1985.

Pamela Pettler and Amy Heckerling, THE NO-SEX HANDBOOK.
Warner Books, 1990.

Jack Prelutsky, THERE'LL BE A SLIGHT DELAY. William Morrow, 1991.

Robert P. Libbon, BYTE ME! Boulevard Books, 1996.

SELECTED DRAWINGS

THE NEW YORKER ALBUM OF DRAWINGS, 1925–1975.
Viking Press, 1975.

THE NEW YORKER CARTOON ALBUM, 1975–1985.
Viking Press, 1985.

THE COMPLETE BOOK OF COVERS FROM THE NEW YORKER, 1925–1989.
Alfred A. Knopf, 1989.

THE ART OF THE NEW YORKER, 1925–1995. Alfred A. Knopf, Inc., 1995.

THE NEW YORKER 75TH ANNIVERSARY CARTOON COLLECTION.
Pocket Books, 1999.

JACK ZIEGLER was born and reared in Queens, a borough of New York City. A conservative upbringing—choirboy, military school—was decisively subverted by his childhood passions for comic books, sitcoms, and rock and roll. After several disastrous career moves, including a failed attempt by the U.S. Army to make him a spy, Jack was guided into the peculiar world of cartooning by a childhood friend. His native, but untutored, gifts were honed by a series of kindly editors, most notably Harvey Kurtzman, the founding genius of *MAD* comics.

Mr. Ziegler published his first comic drawings in *National Lampoon* and has been a prolific contributor to *The New Yorker* since 1974. He and his wife Kelli live and work in Las Vegas, Nevada.

LEE LORENZ has been a cartoonist for *The New Yorker* since 1958. From 1973 to 1993 he also served as the magazine's art editor, continuing as cartoon editor until 1997. His previous books include *The Art of The New Yorker, The Essential George Booth, The Essential Charles Barsotti,* and *The World of William Steig.*

Mr. Lorenz lives and works in Fairfield County, Connecticut.